# YTAK
drawings by Katy Watts

# Introduction

YTAK aka Katy Watts is a self-taught artist from the UK, though she has had some art school training. She is currently studying for an Open University degree. Katy creates colourful and bright art. Included in her work are many imaginary creatures and townscapes. It is her hope that the viewer can 'step into' these works, leaving behind everyday worries and anxieties. That for a brief moment they can be transported to a world of colour and possibilities. Katy likes to keep her work playful.
Drawing is central to Katy's work. She likes to combine traditional med with digital drawing software.
Katy is inspired by lots of things, mostly by other artists. She also loves music and finds a huge amount of inspiration there. Generally though, she finds people themselves to be inspiring and interesting.

YTAK is Katy's pseudonym as an artist.

Drawn and illustrated by Katy Watts (YTAK)

All content © 2013 by Katy Watts (YTAK).

All rights reserved.
No part of this publication may be reproduced, utilised or transmitted in any form without the written permission of the copyright owner.

ISBN 978-1-291-47189-2

To see more of Katy's work please visit:

http://www.flickr.com/photos/inksplat

https://www.etsy.com/shop/ytak87

To contact Katy write to Wattskaty@aol.com

IN THE MIDST OF WINTER, I FOUND THERE WAS, WITHIN ME, AN INVINCIBLE SUMMER

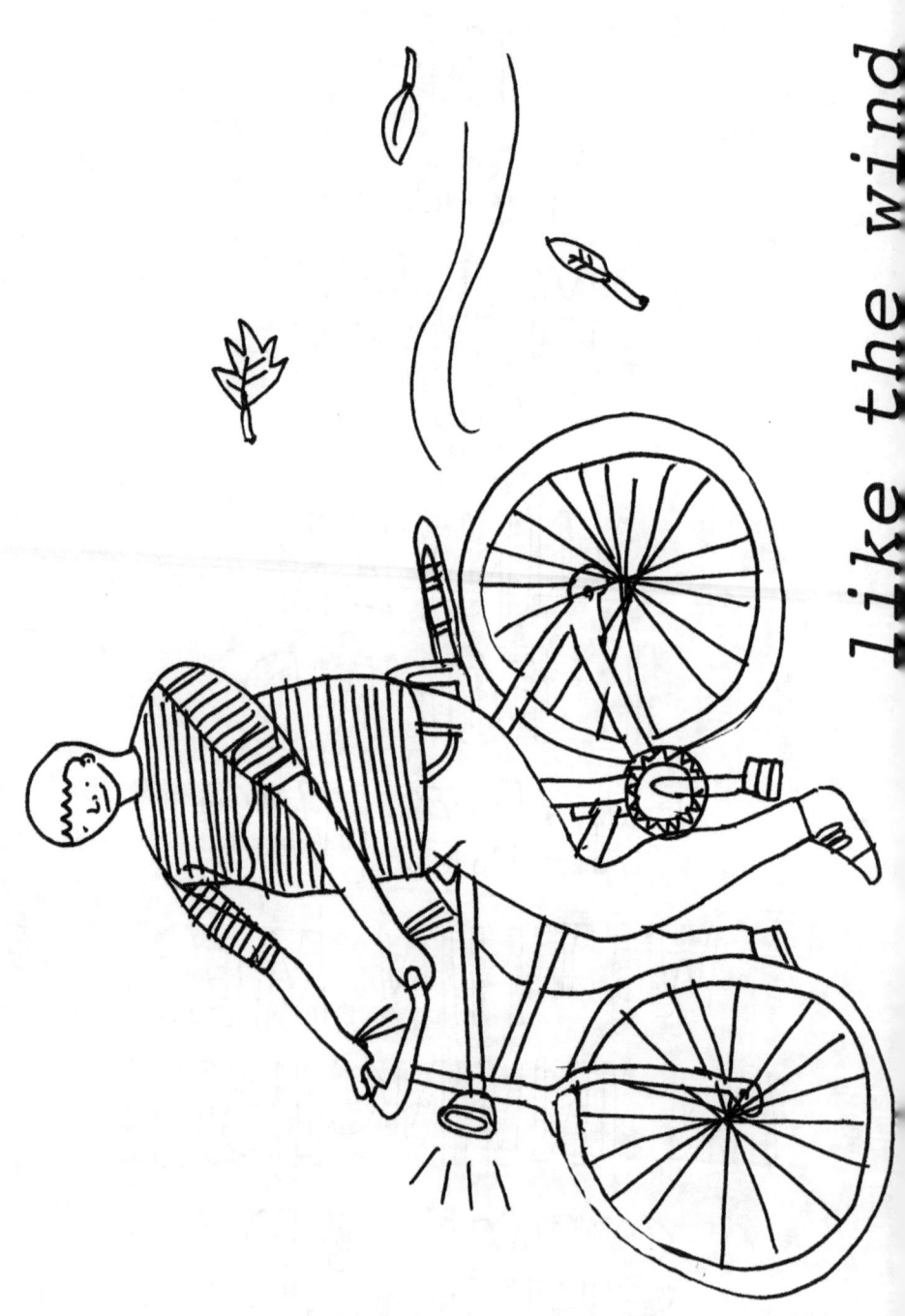

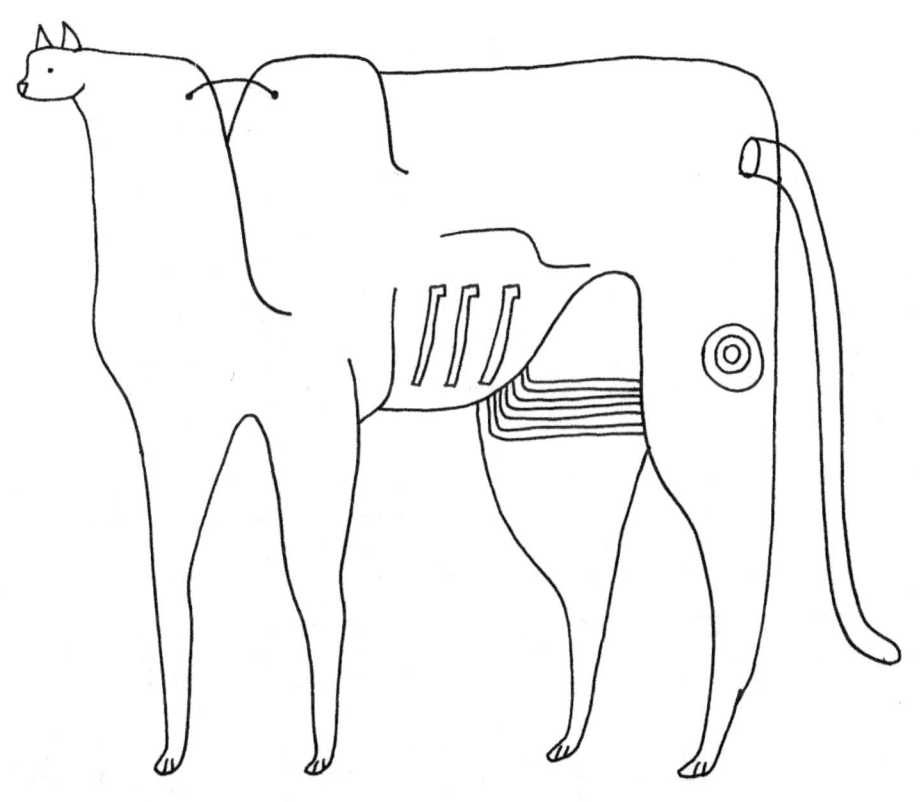

# Cat comic :

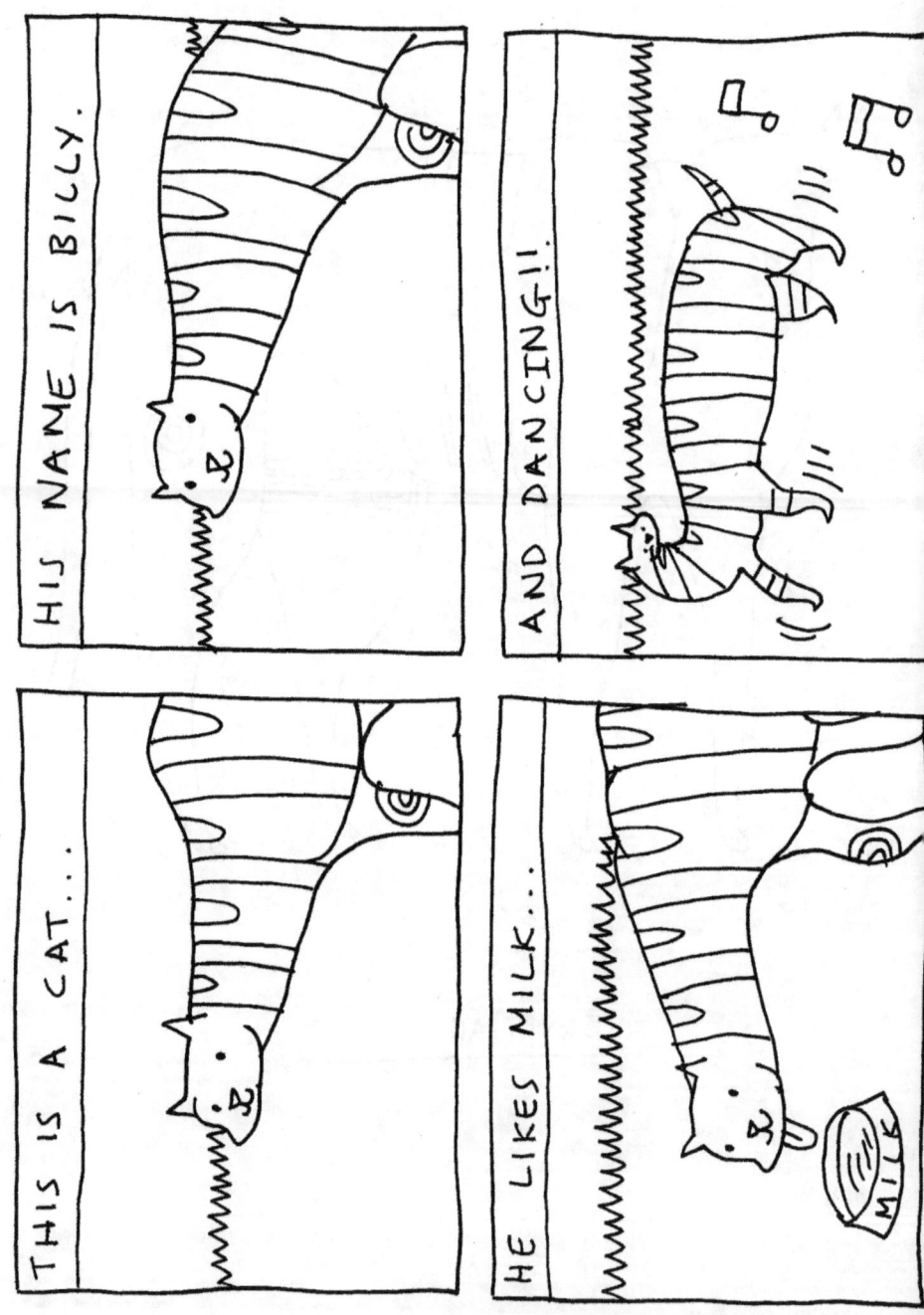

# the allotment

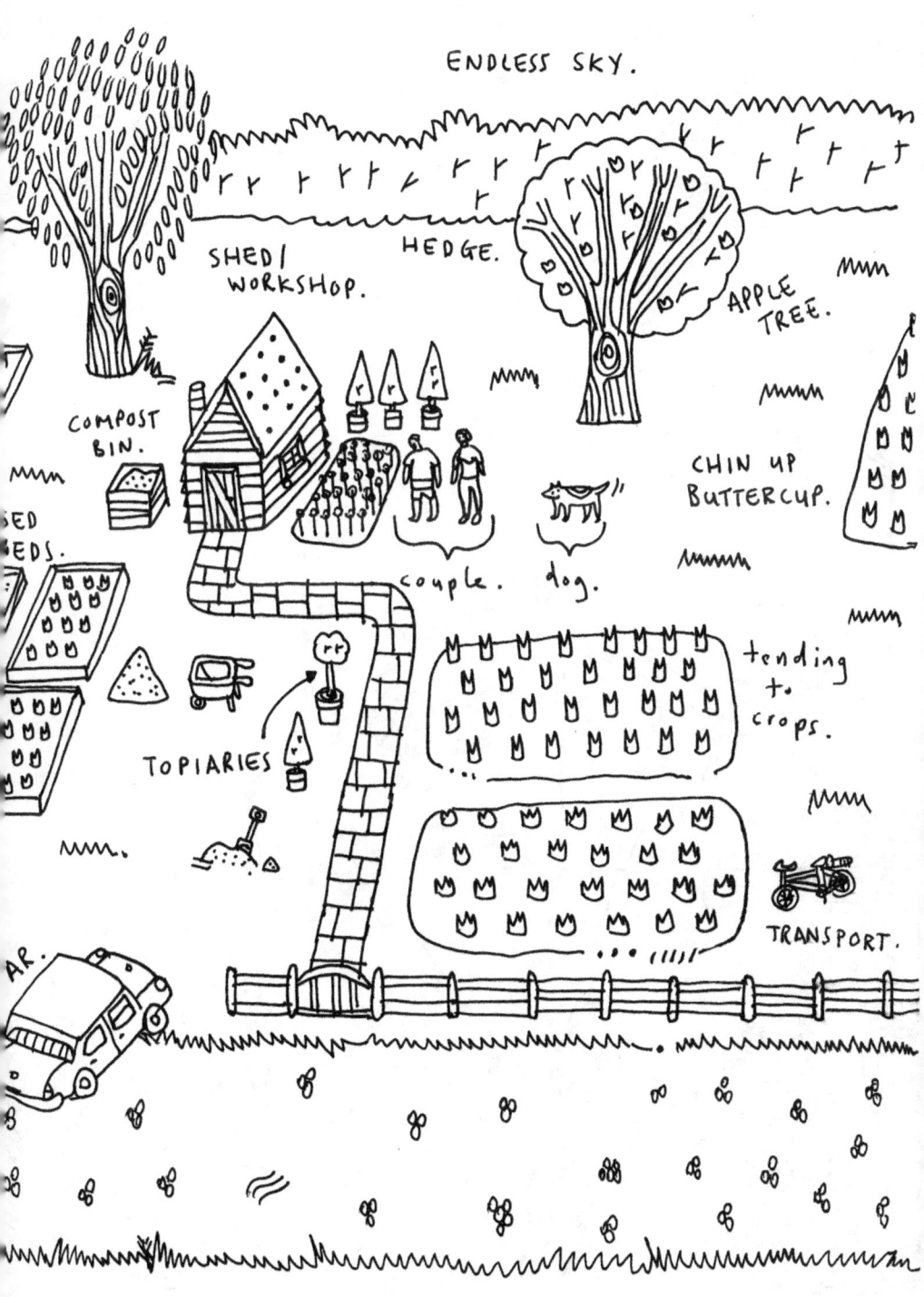

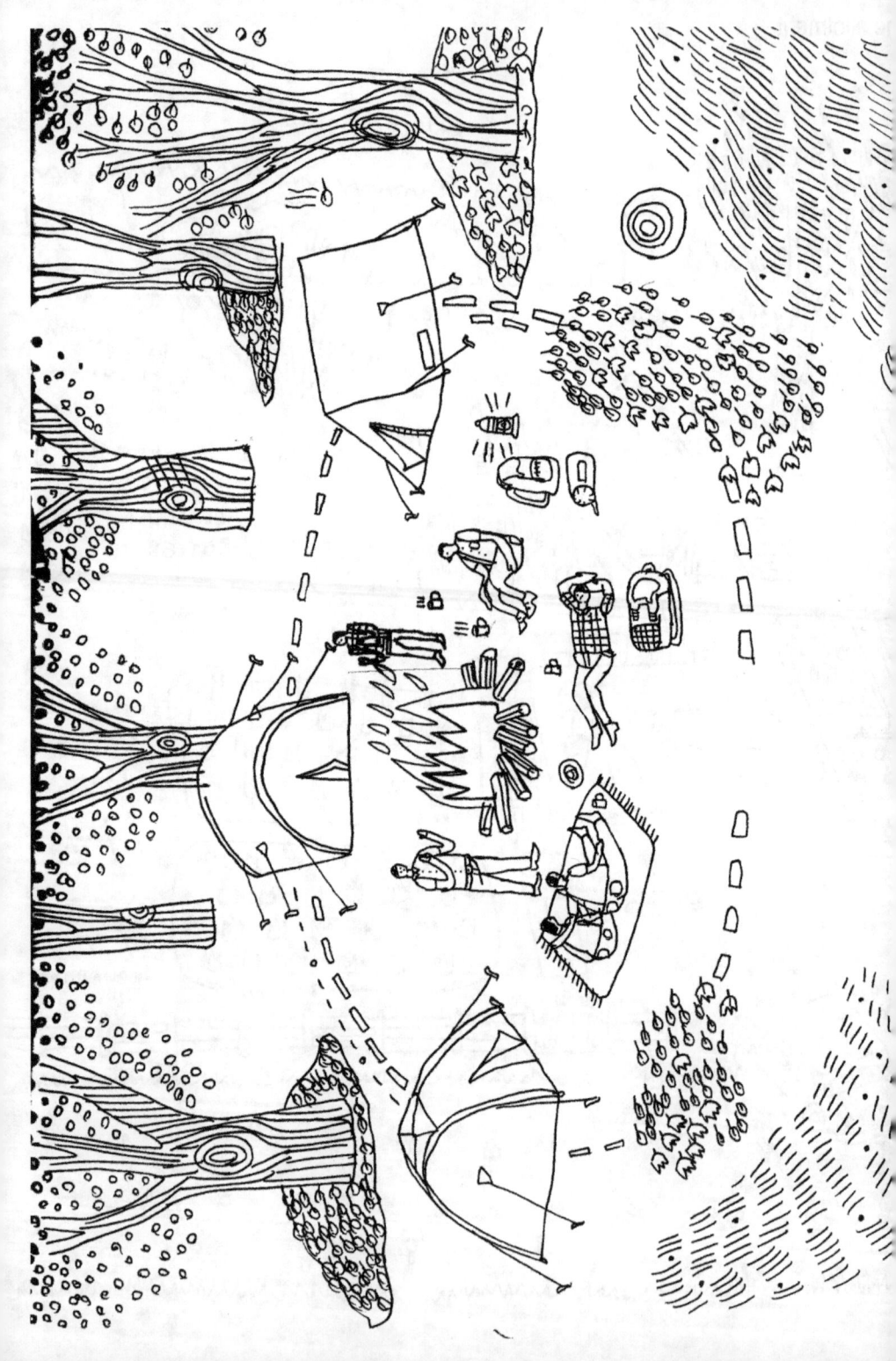

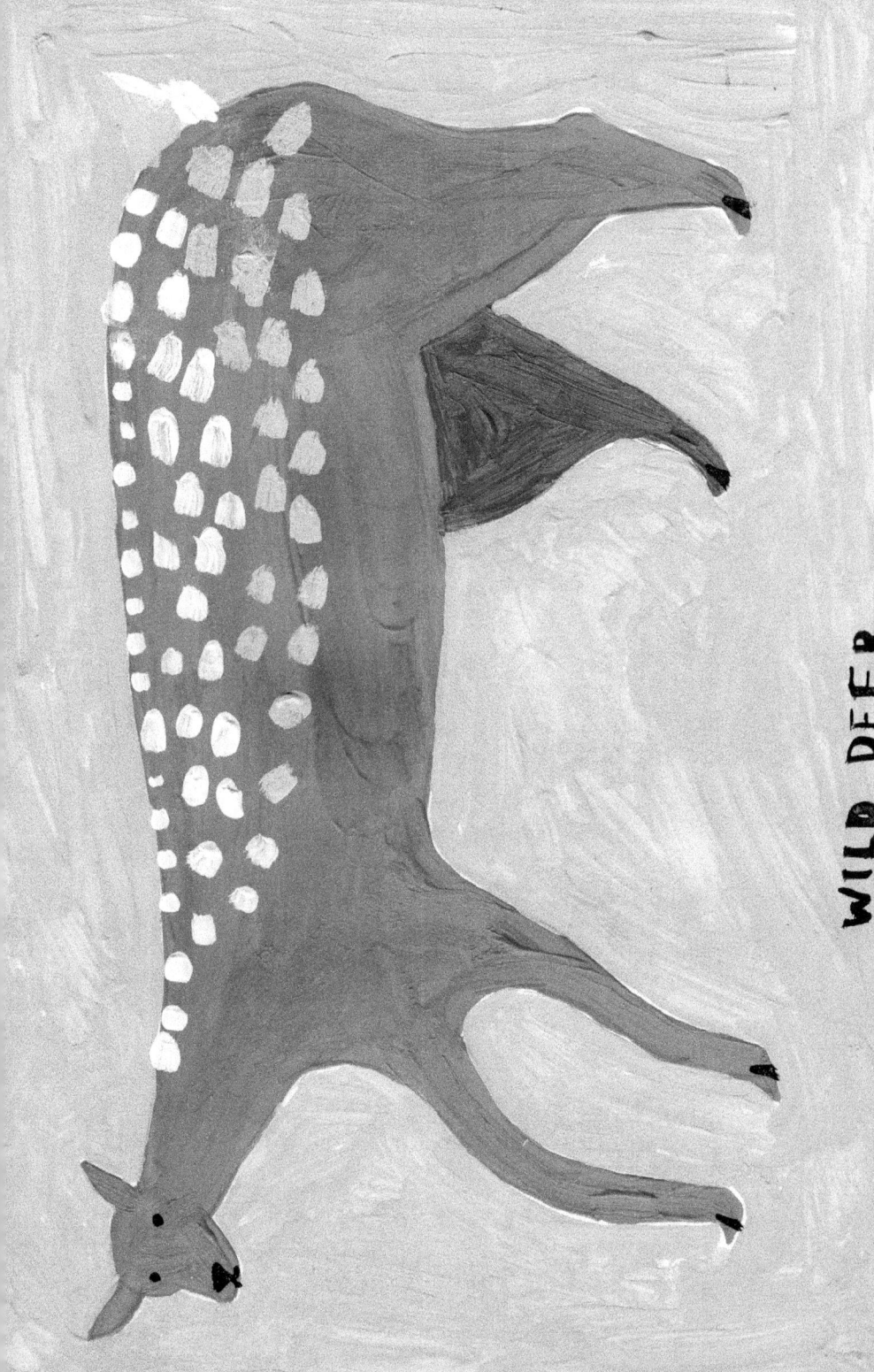

CARS.

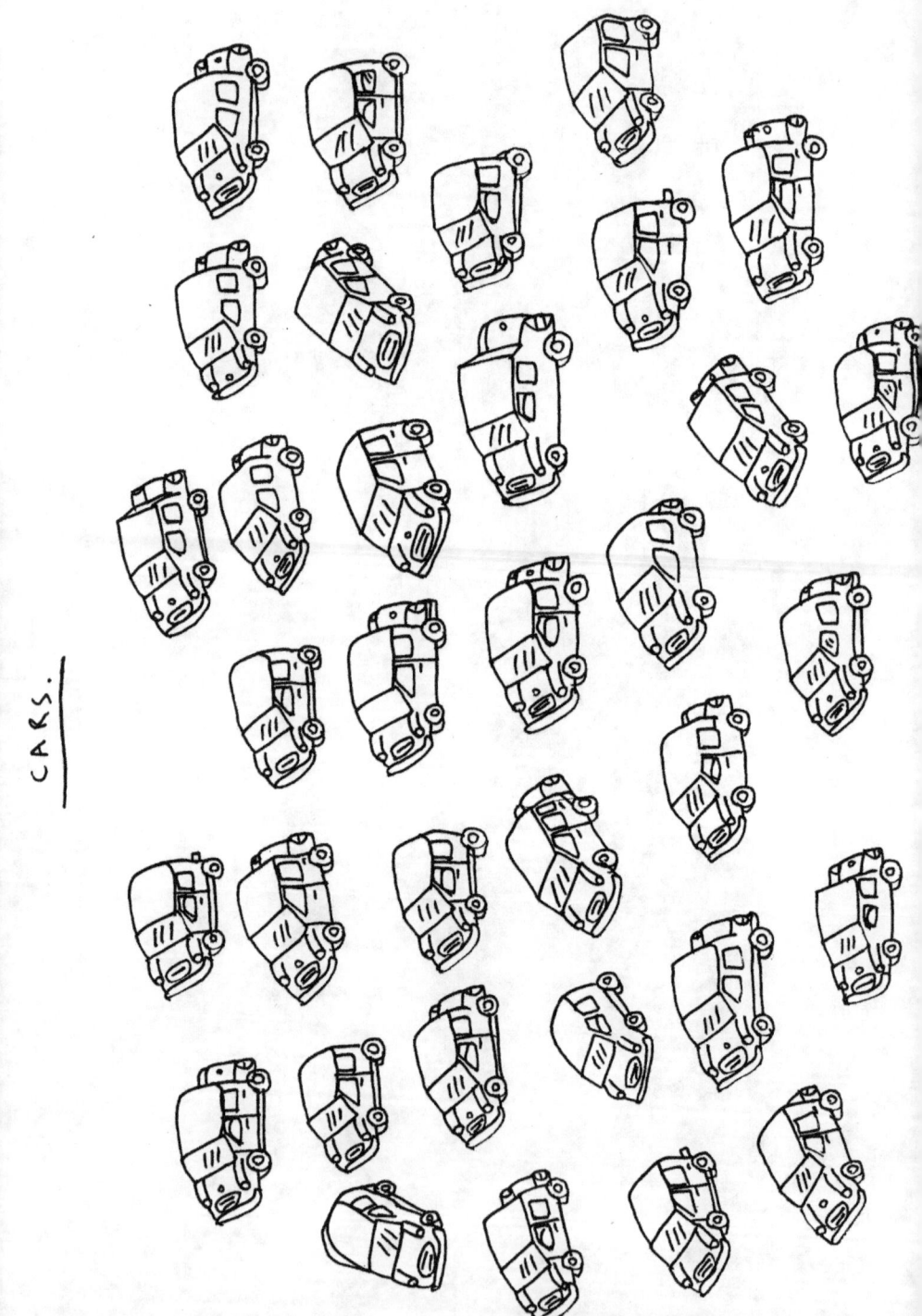

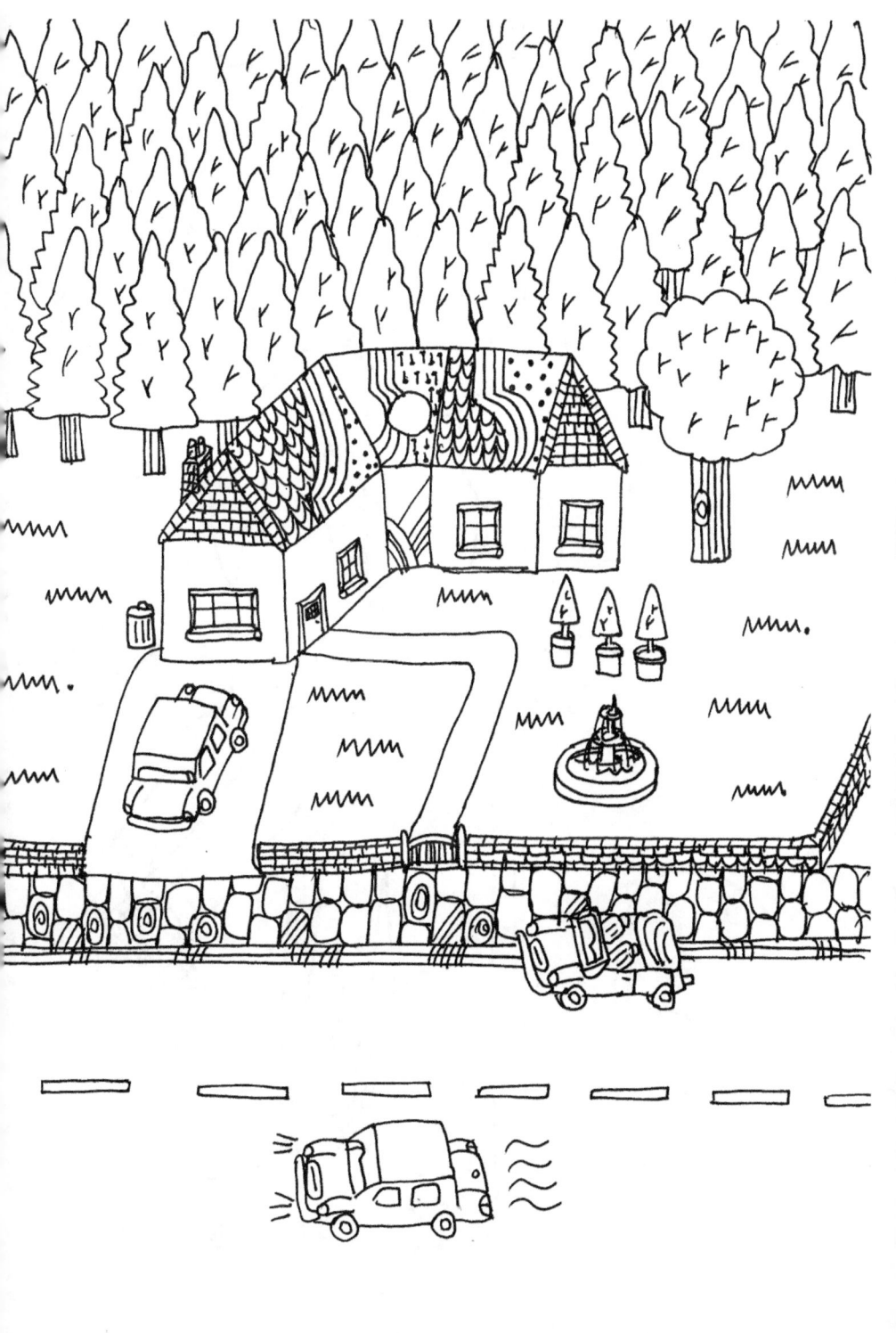

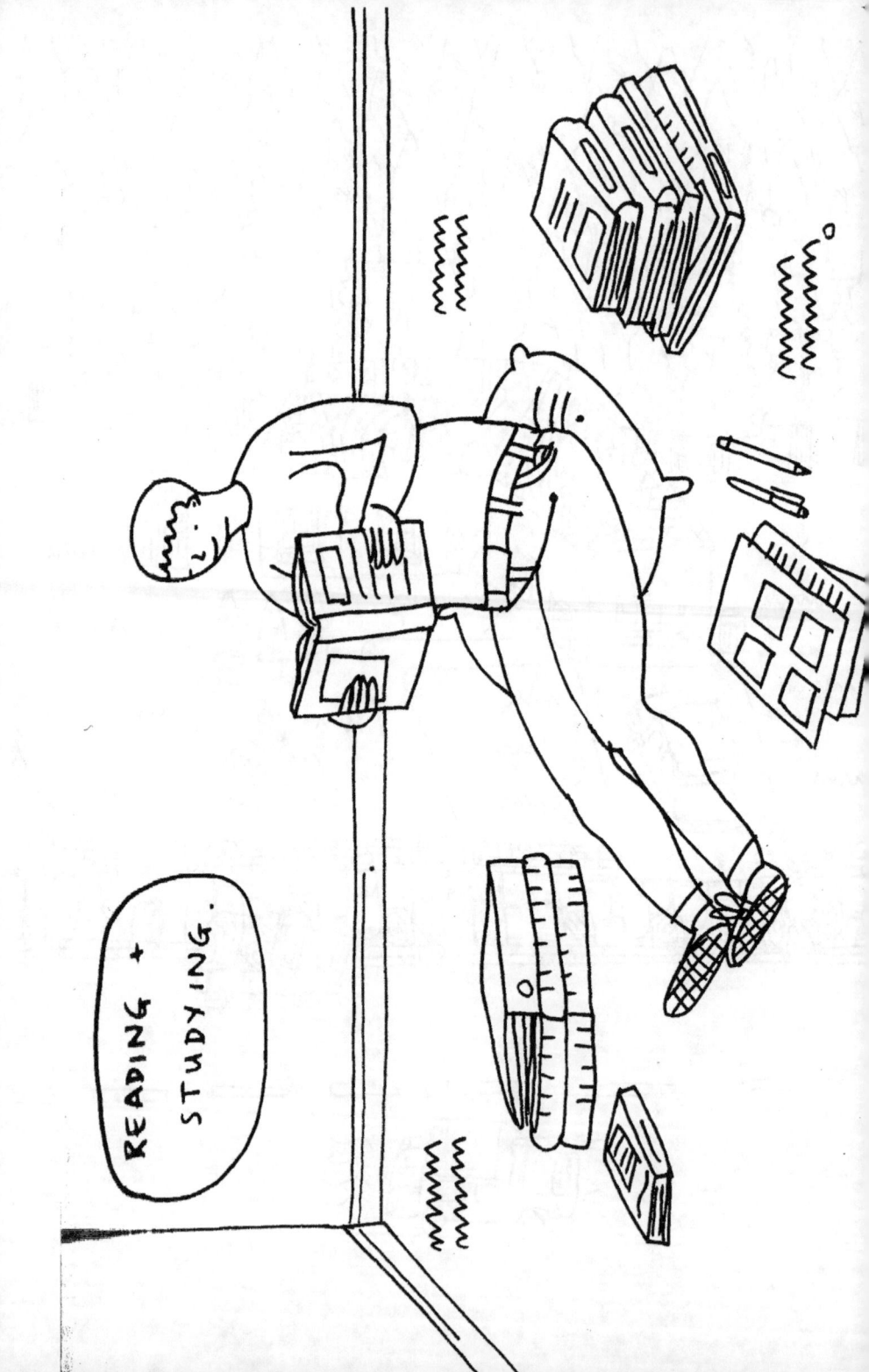

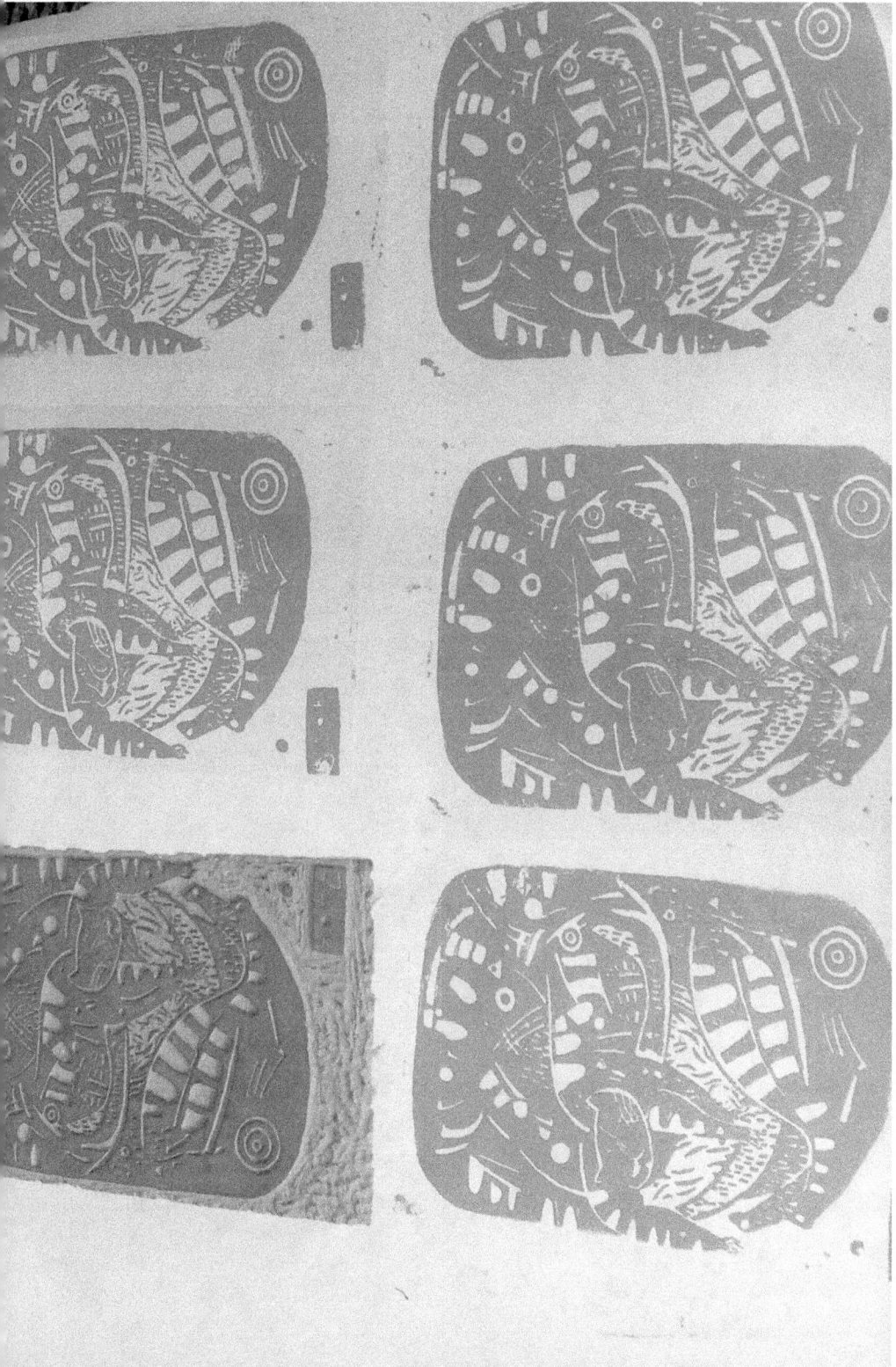

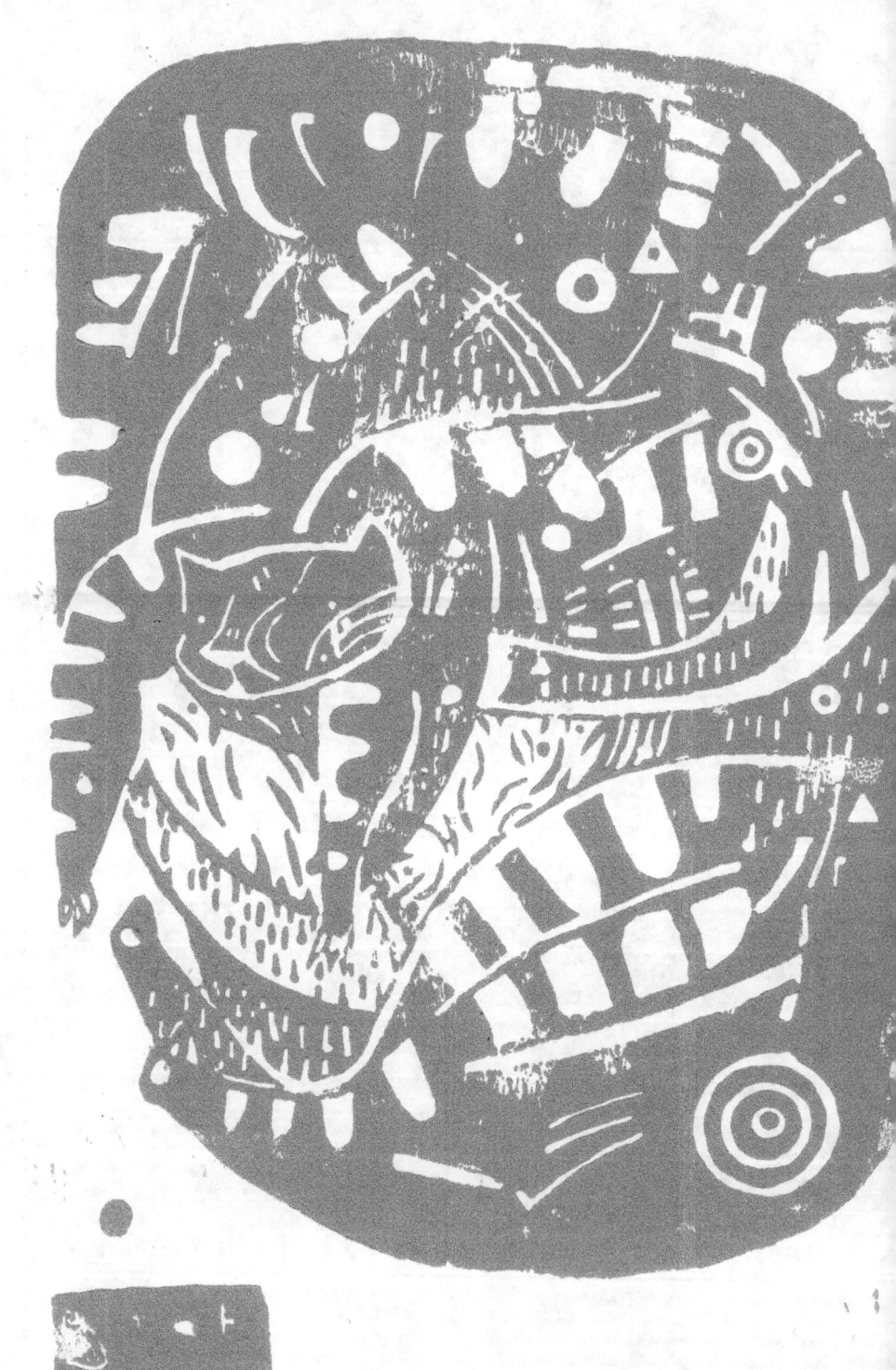

# BERNARD.

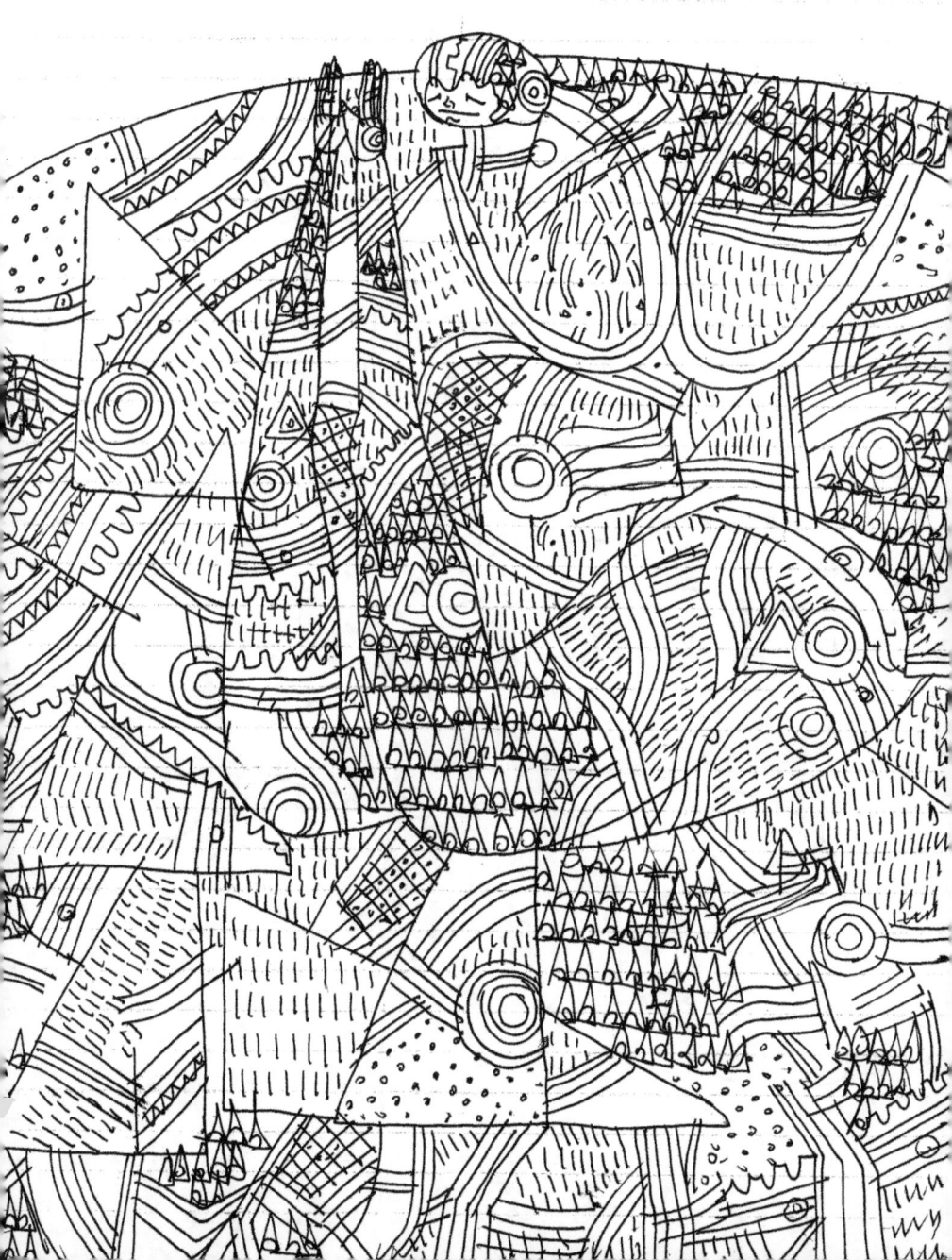

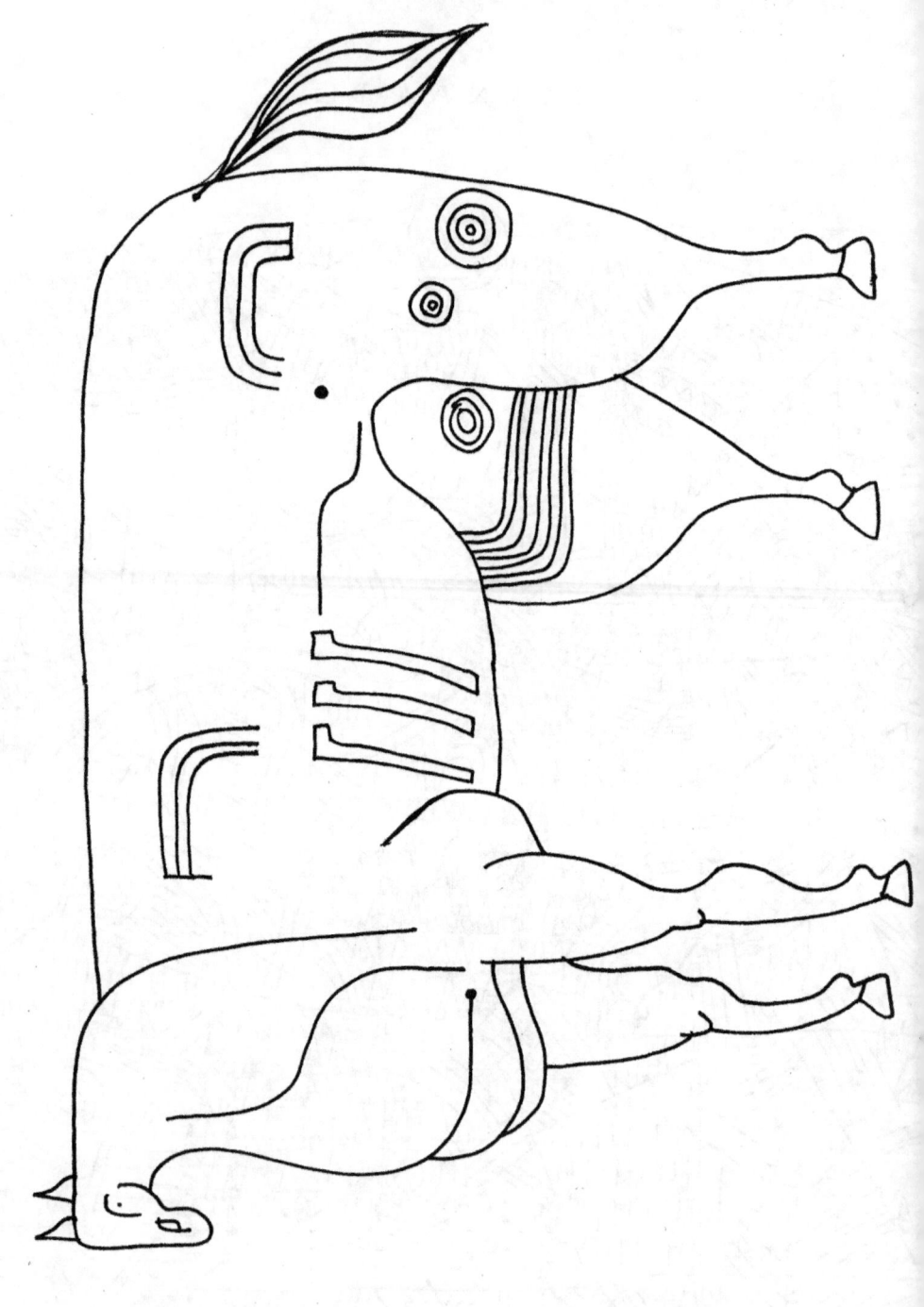

THE CAT.

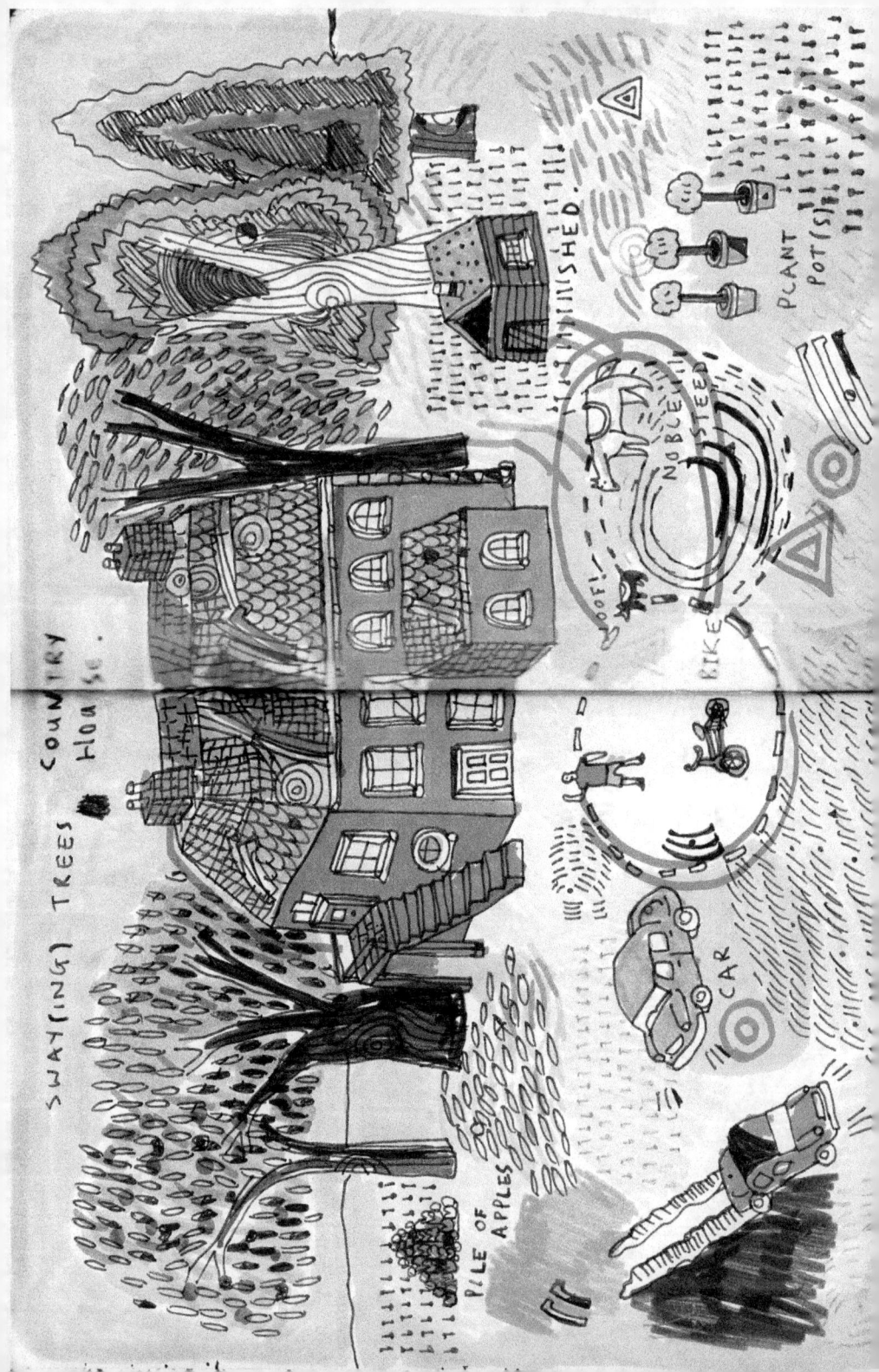

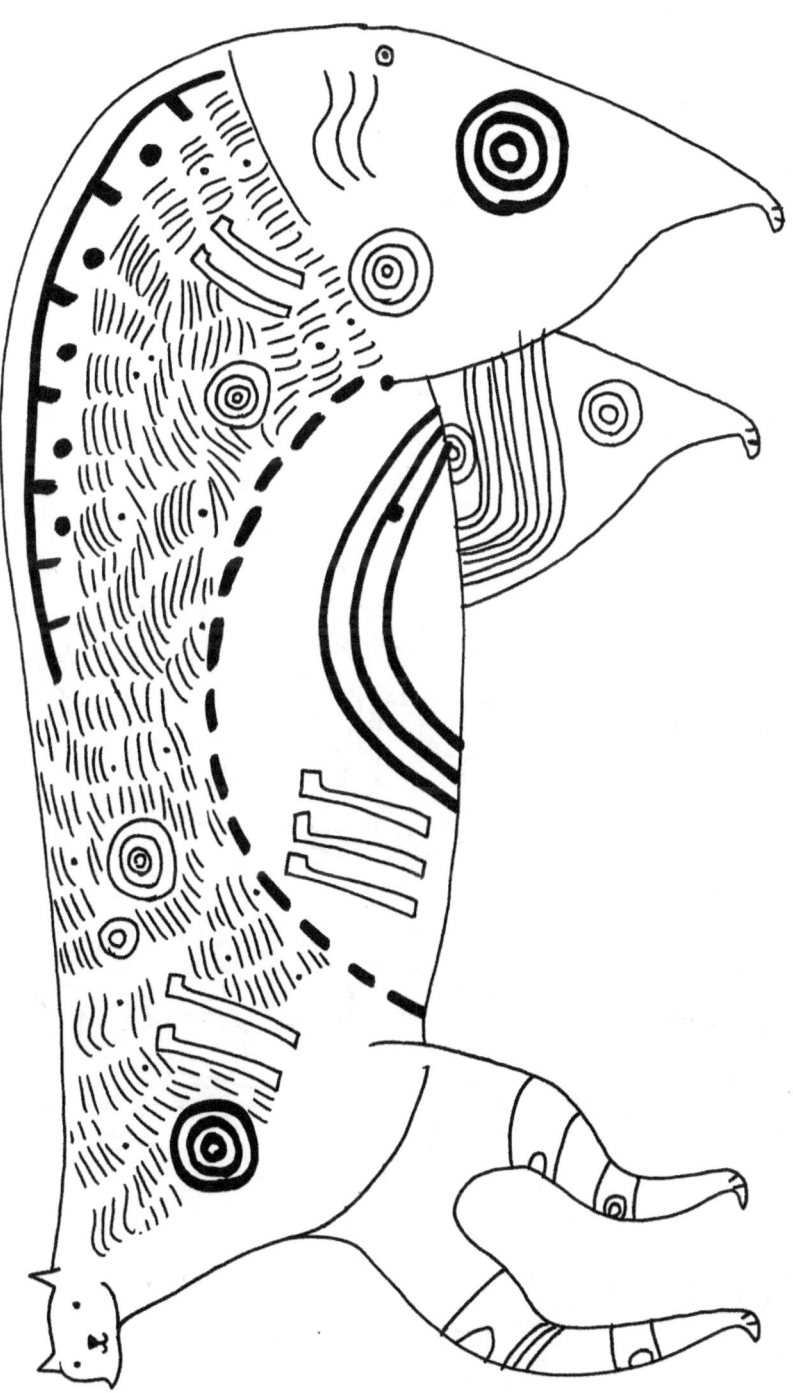

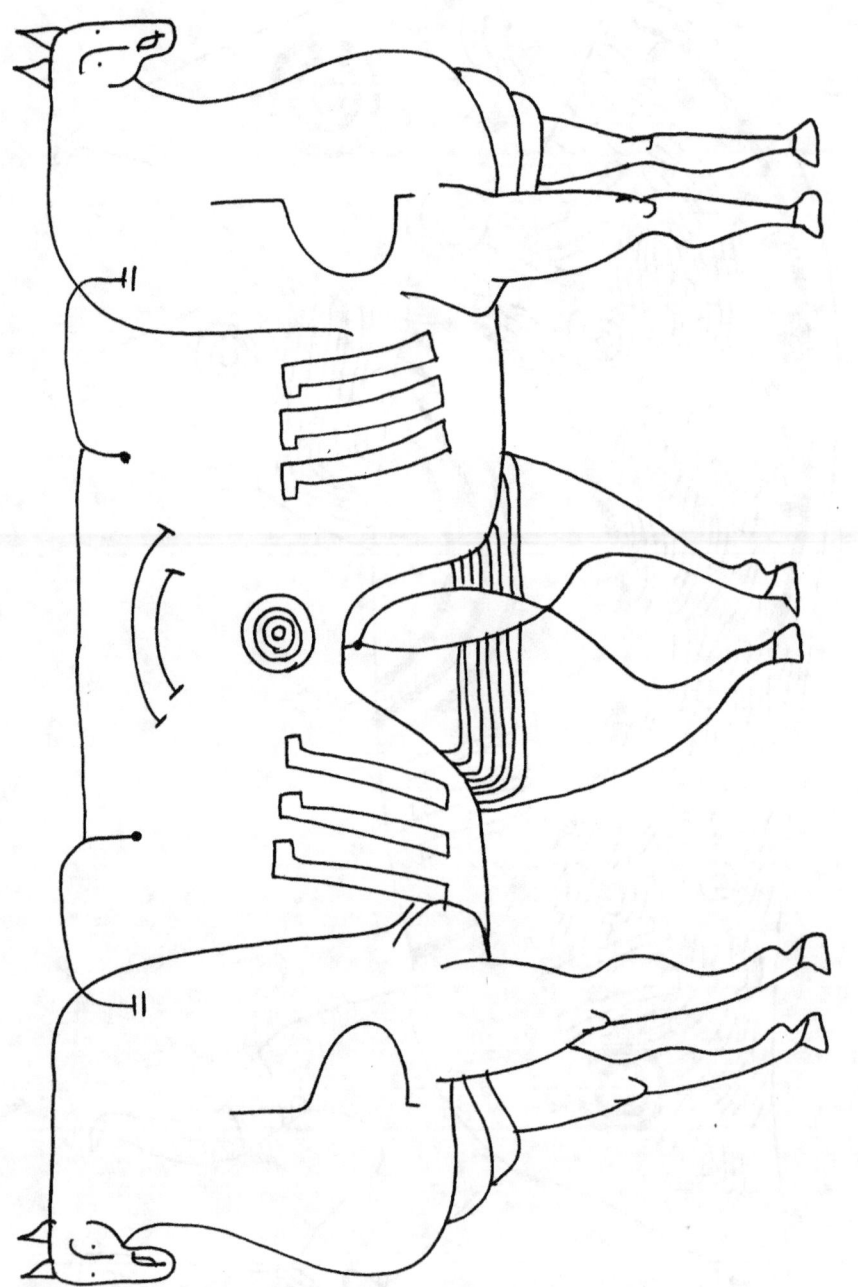

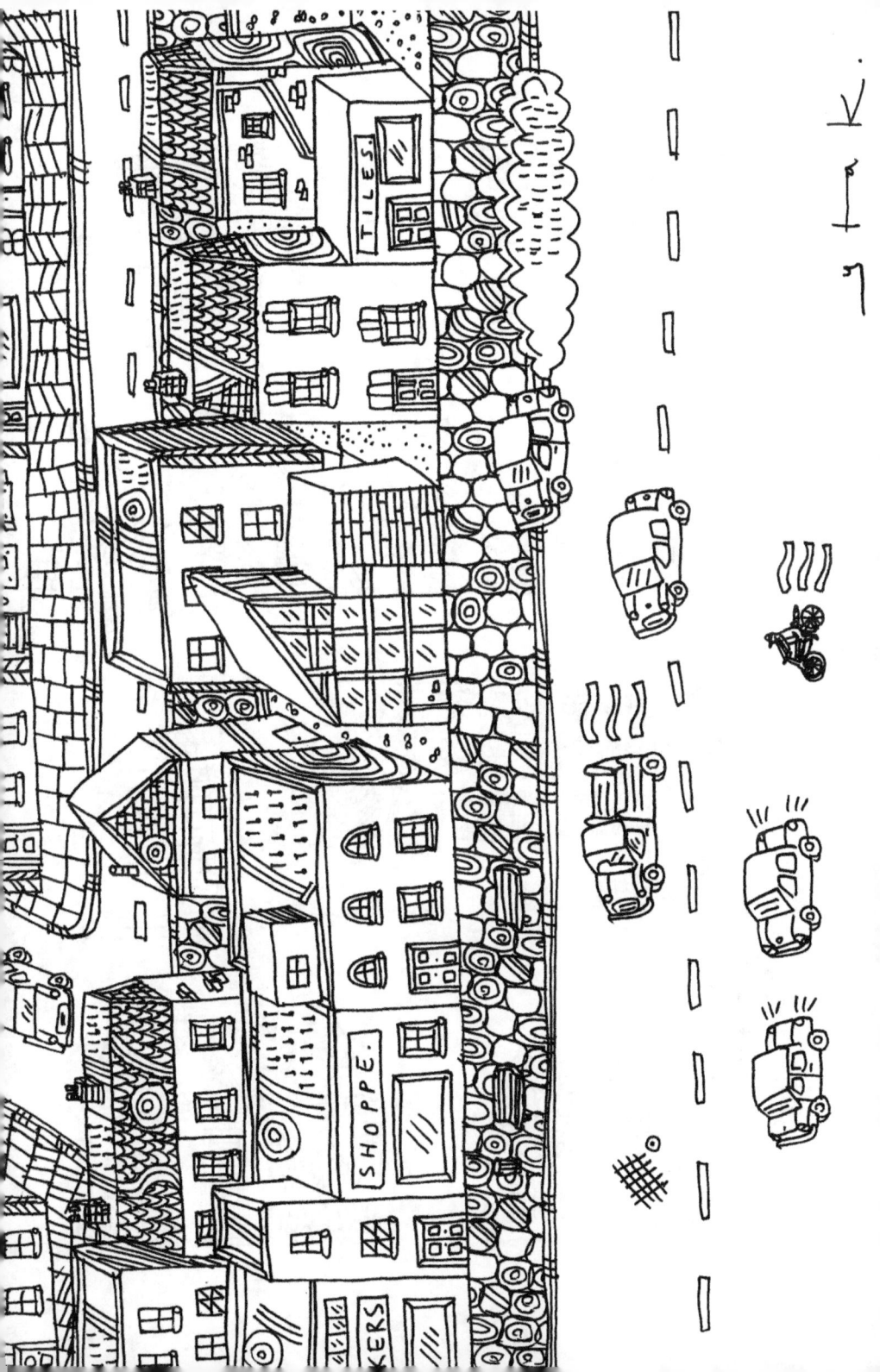

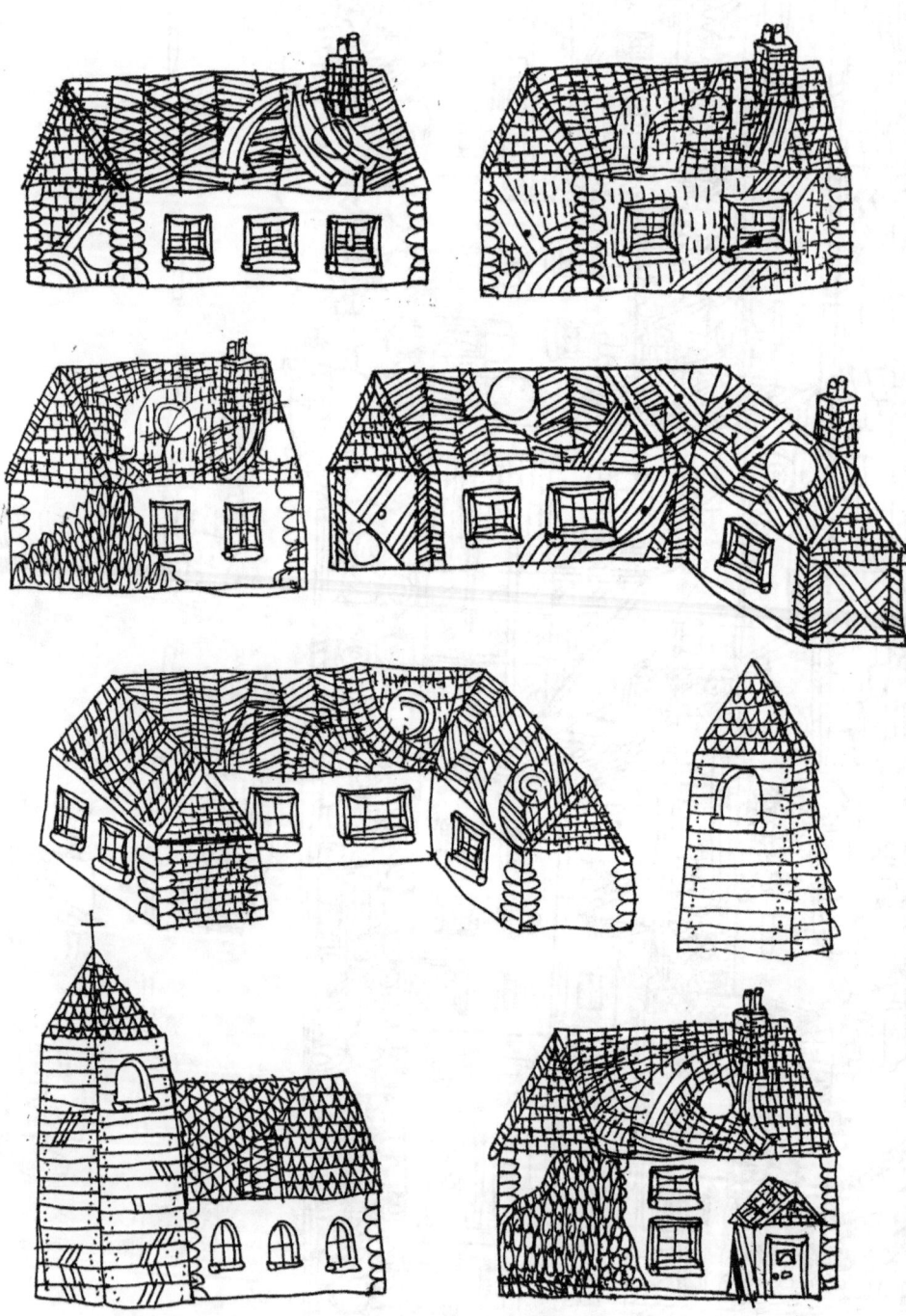

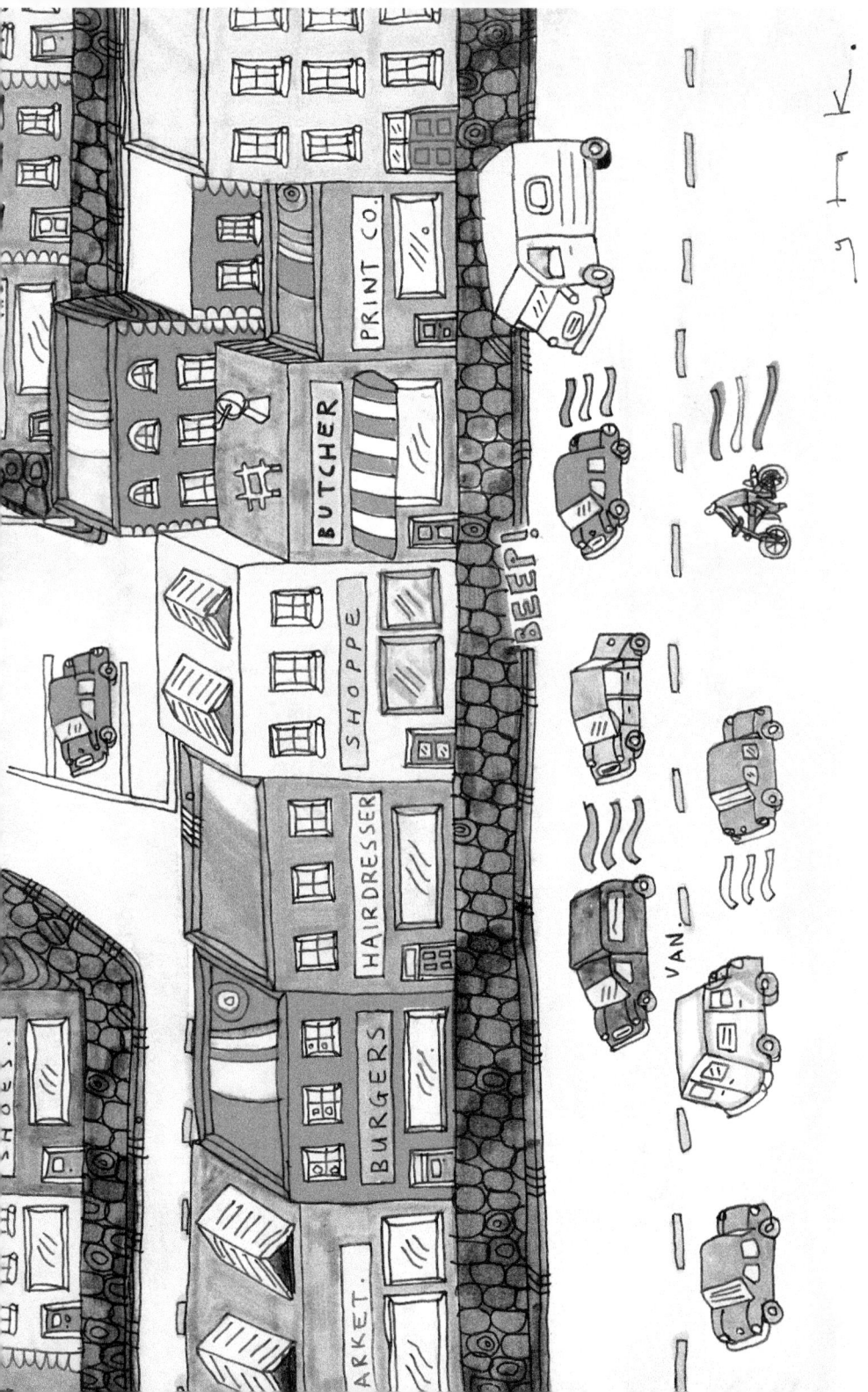

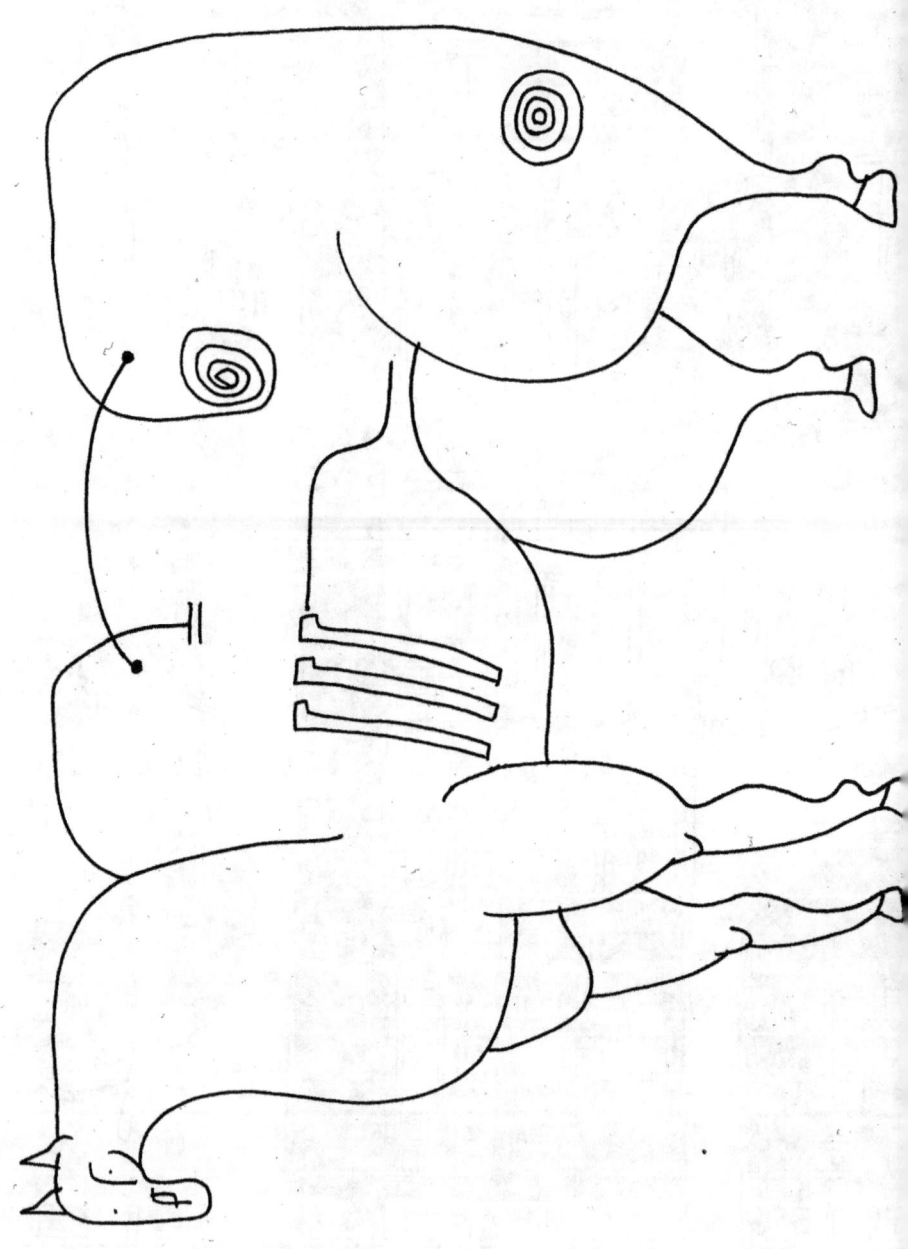

YOU
SHINE
LIKE
TRUTH
IN ALL
YOU
DO

# HIGH HOPES

↑↑↑↑↑↑↑↑

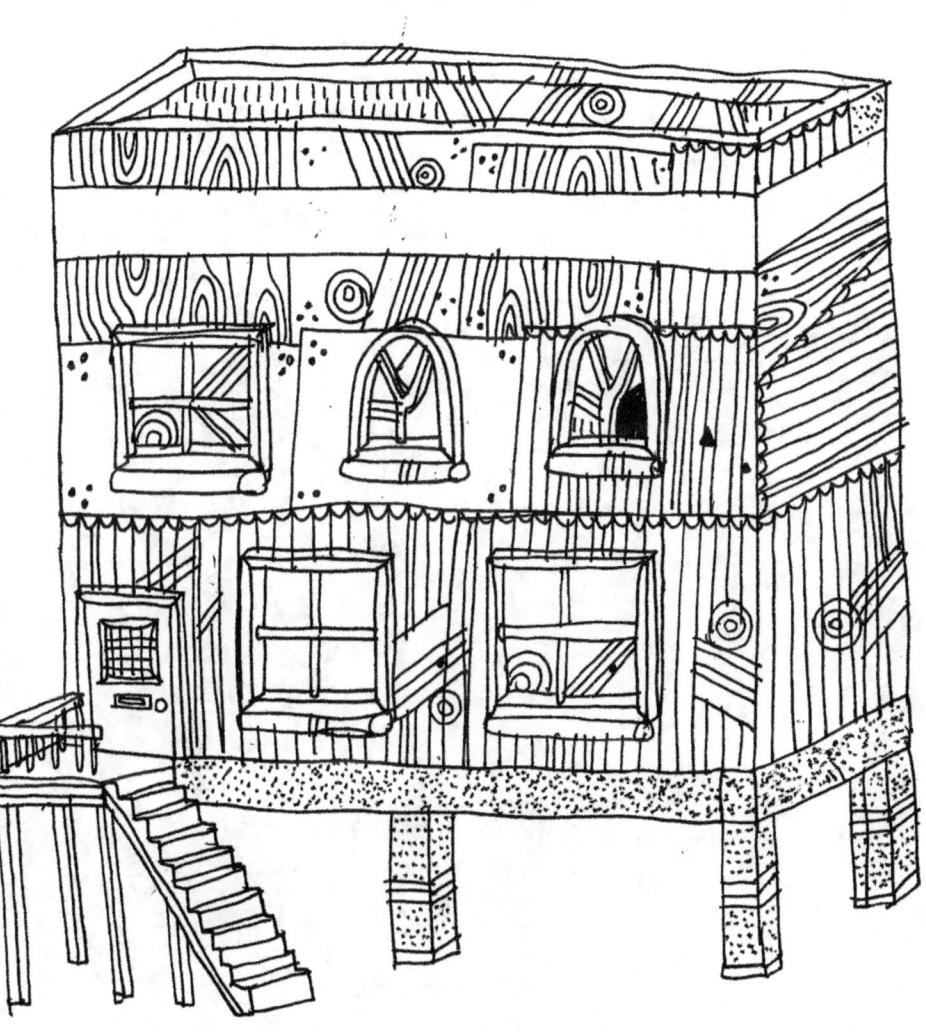

The Iron House

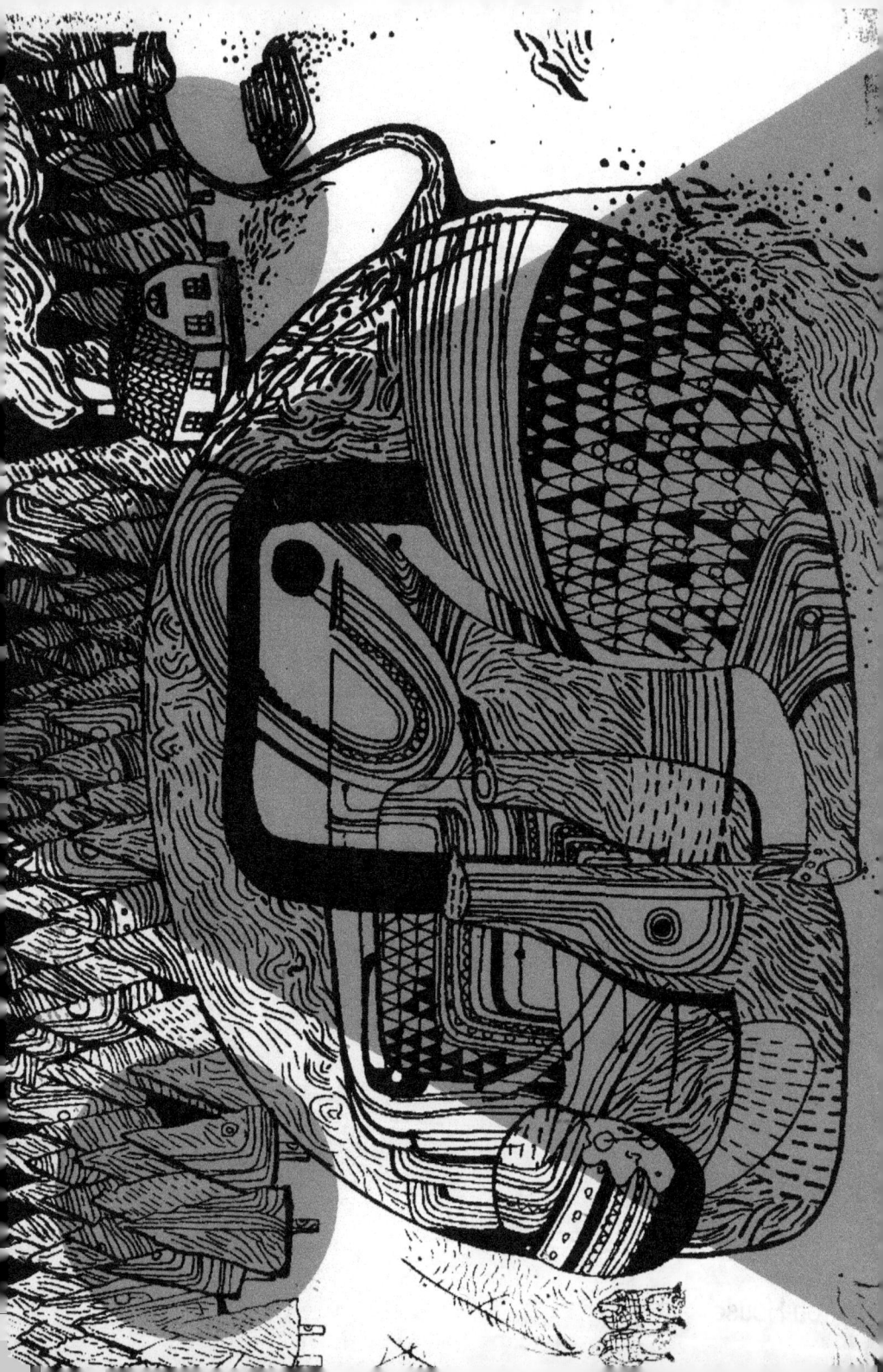

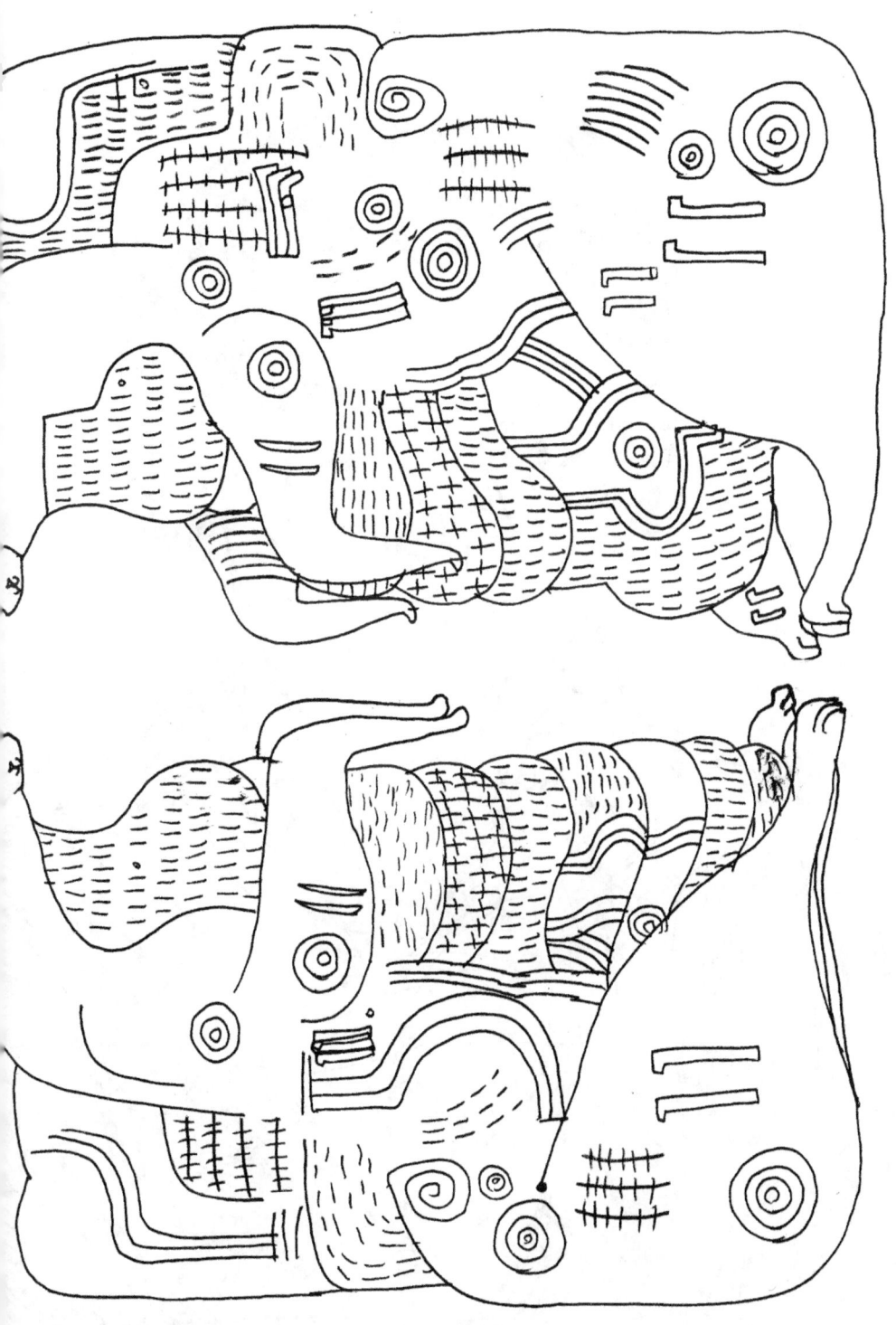

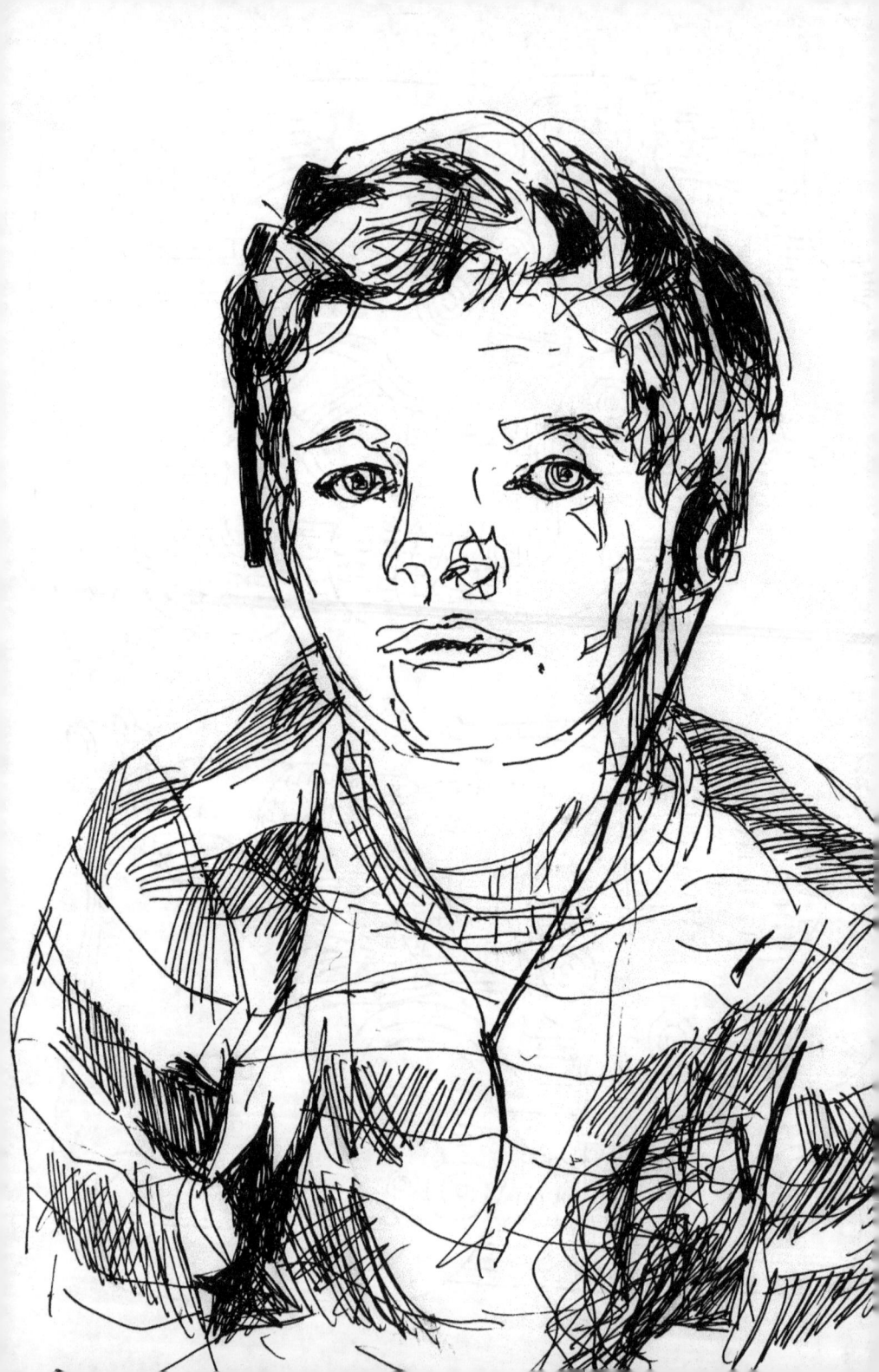

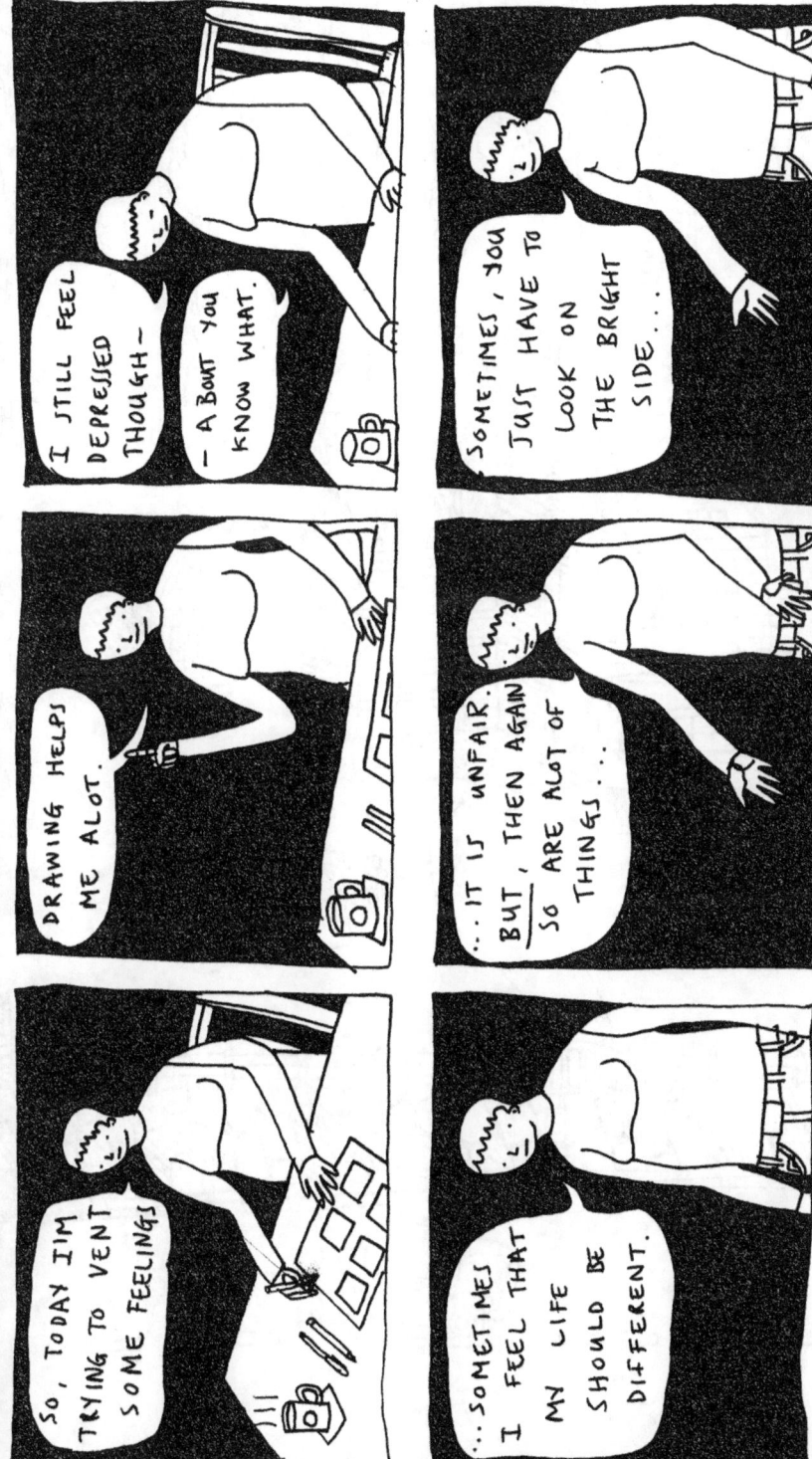

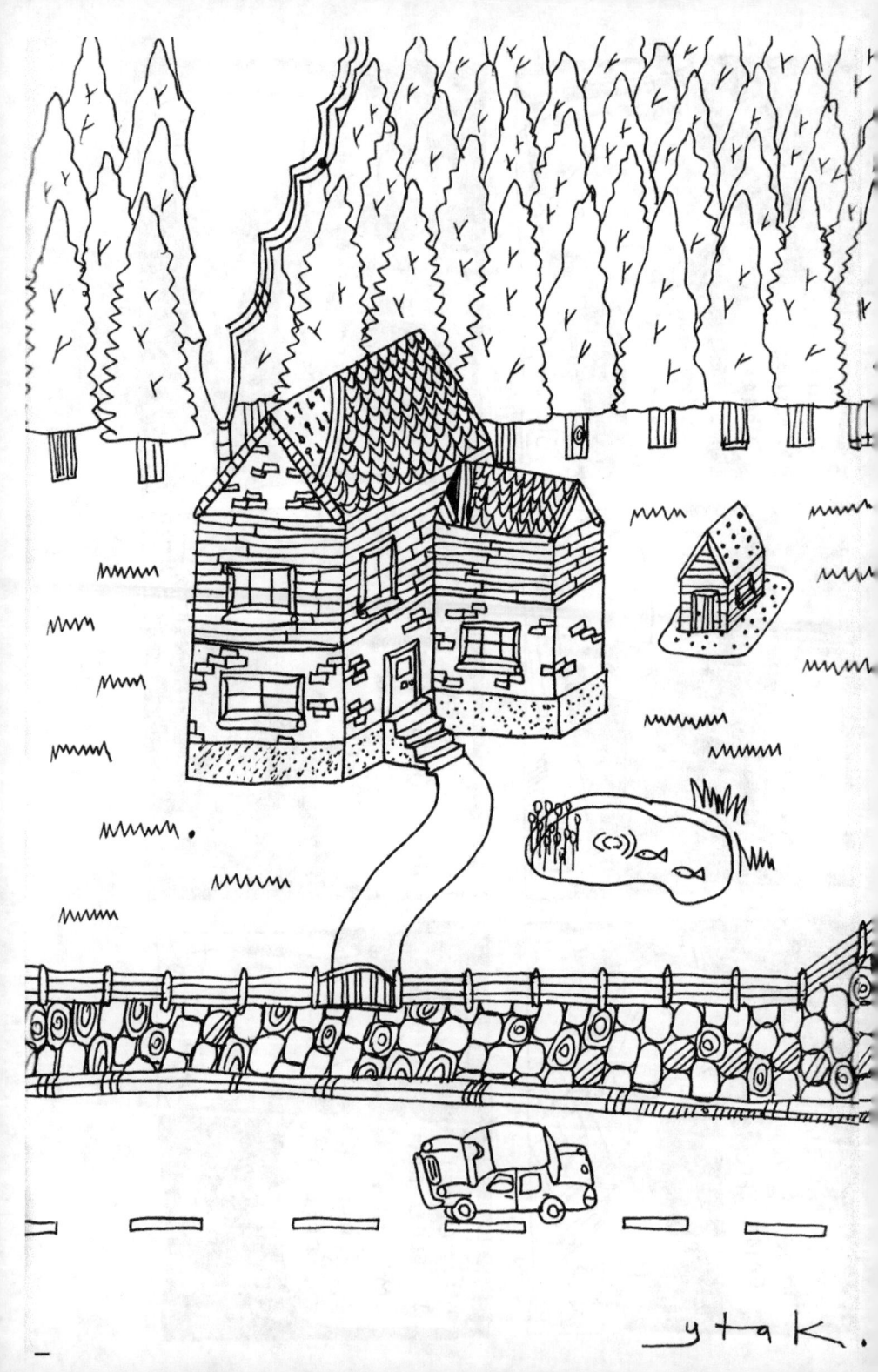

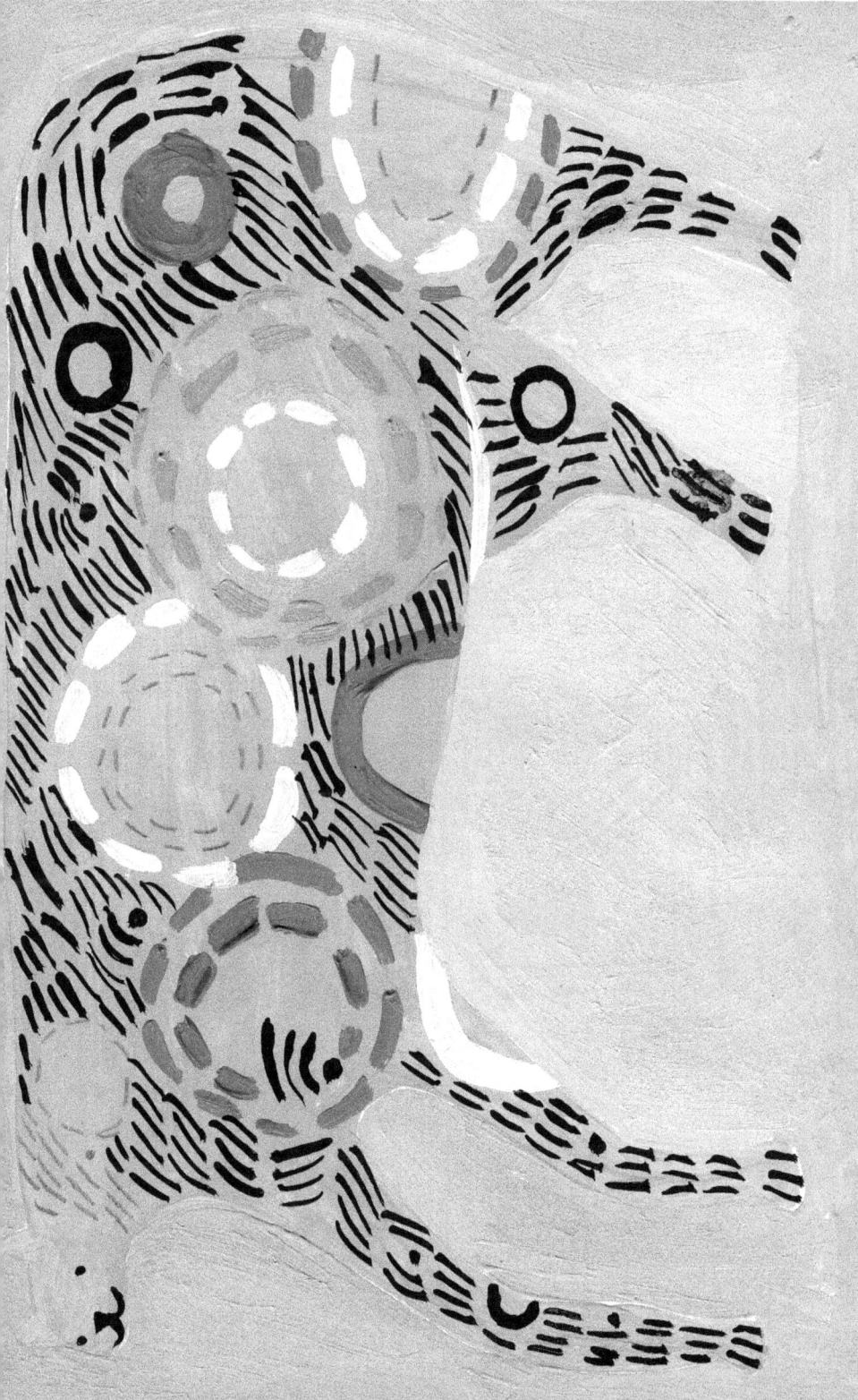

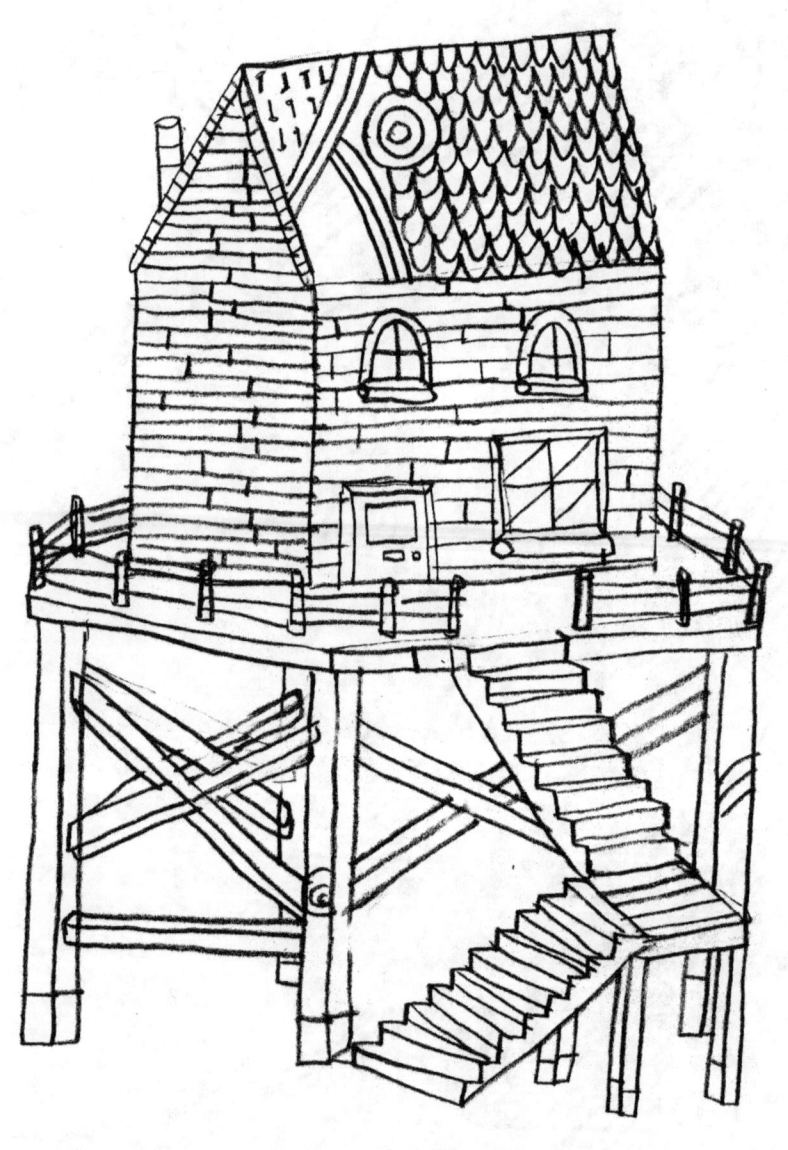

HOUSE ON STILTS.

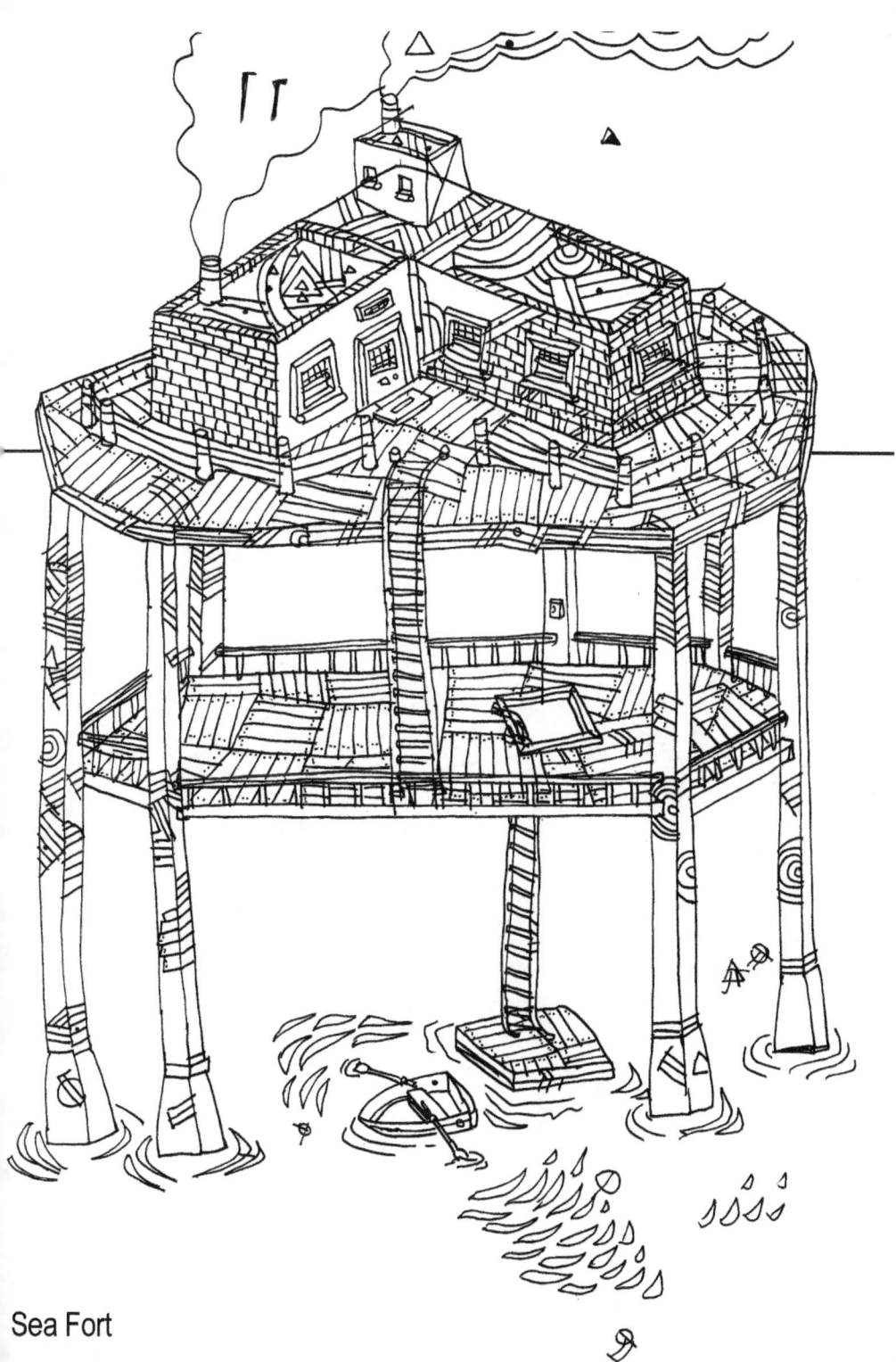

Sea Fort

DOG DAYS.

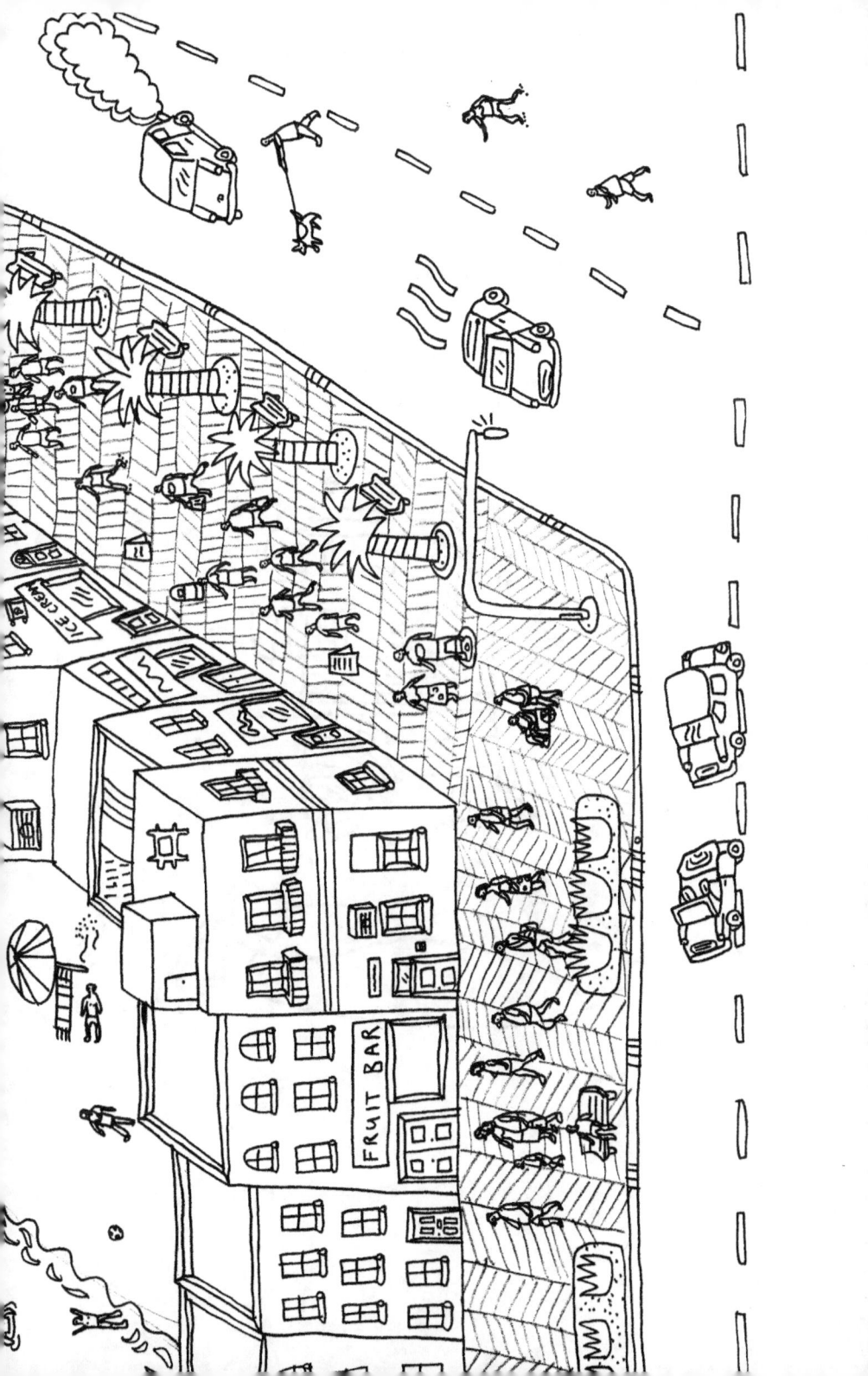

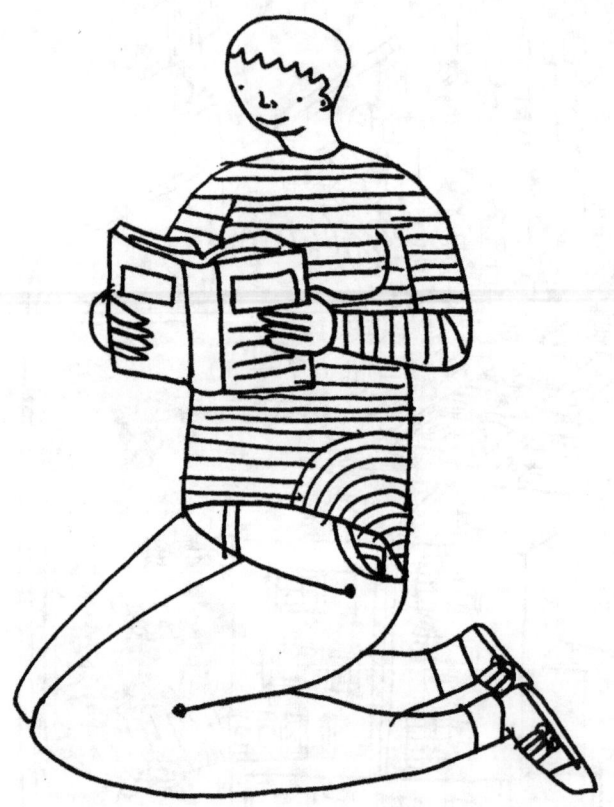

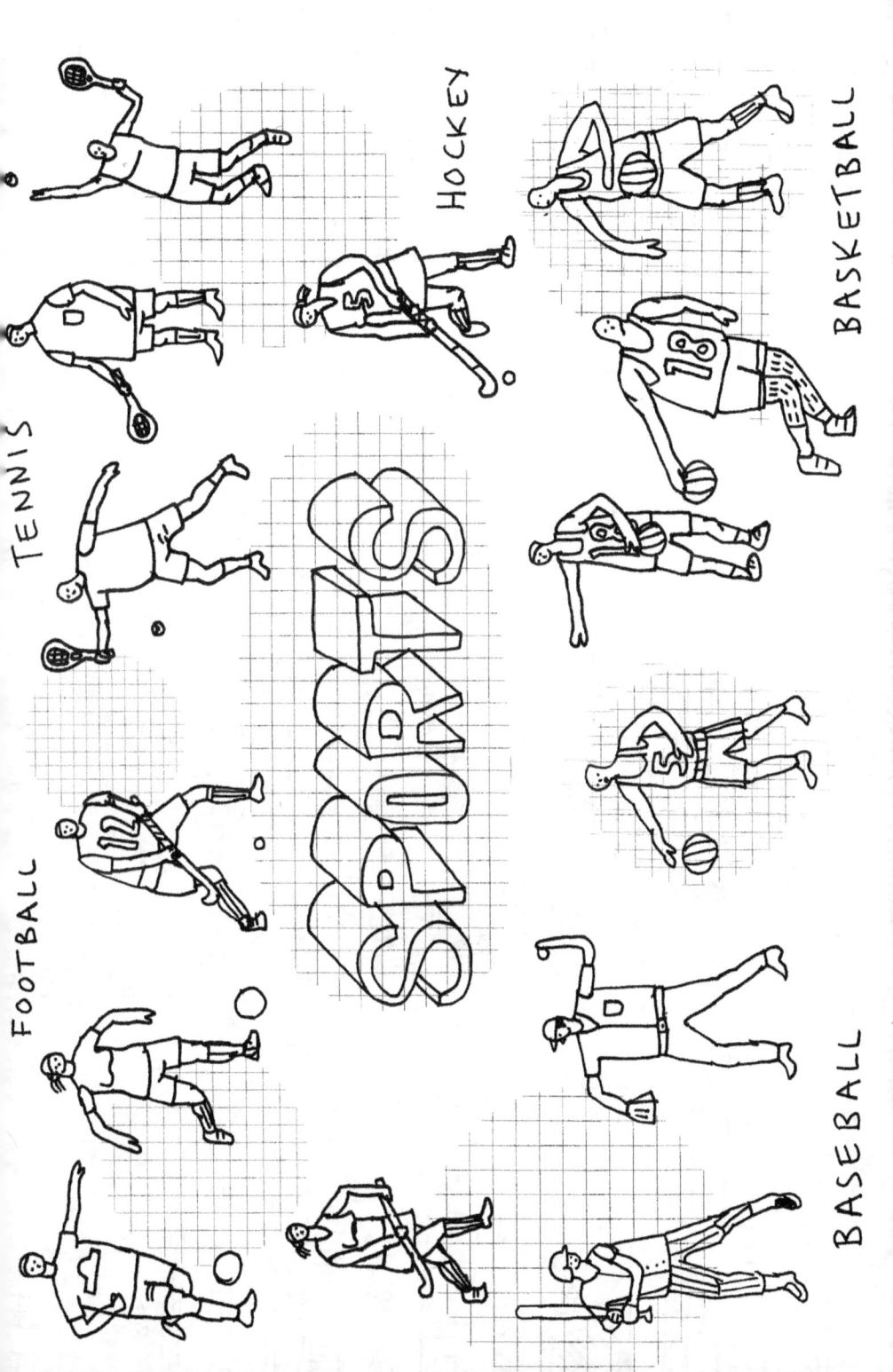

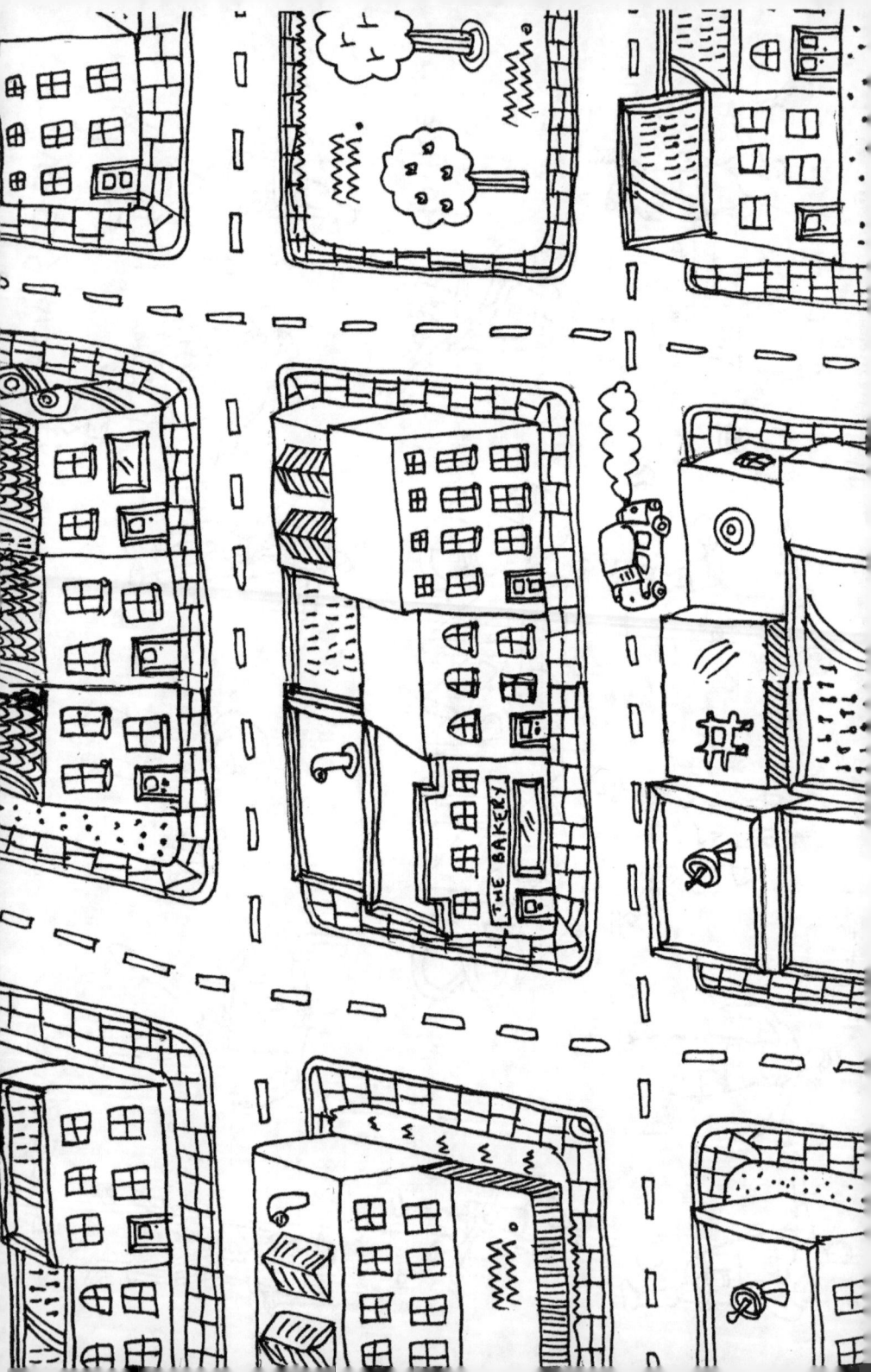

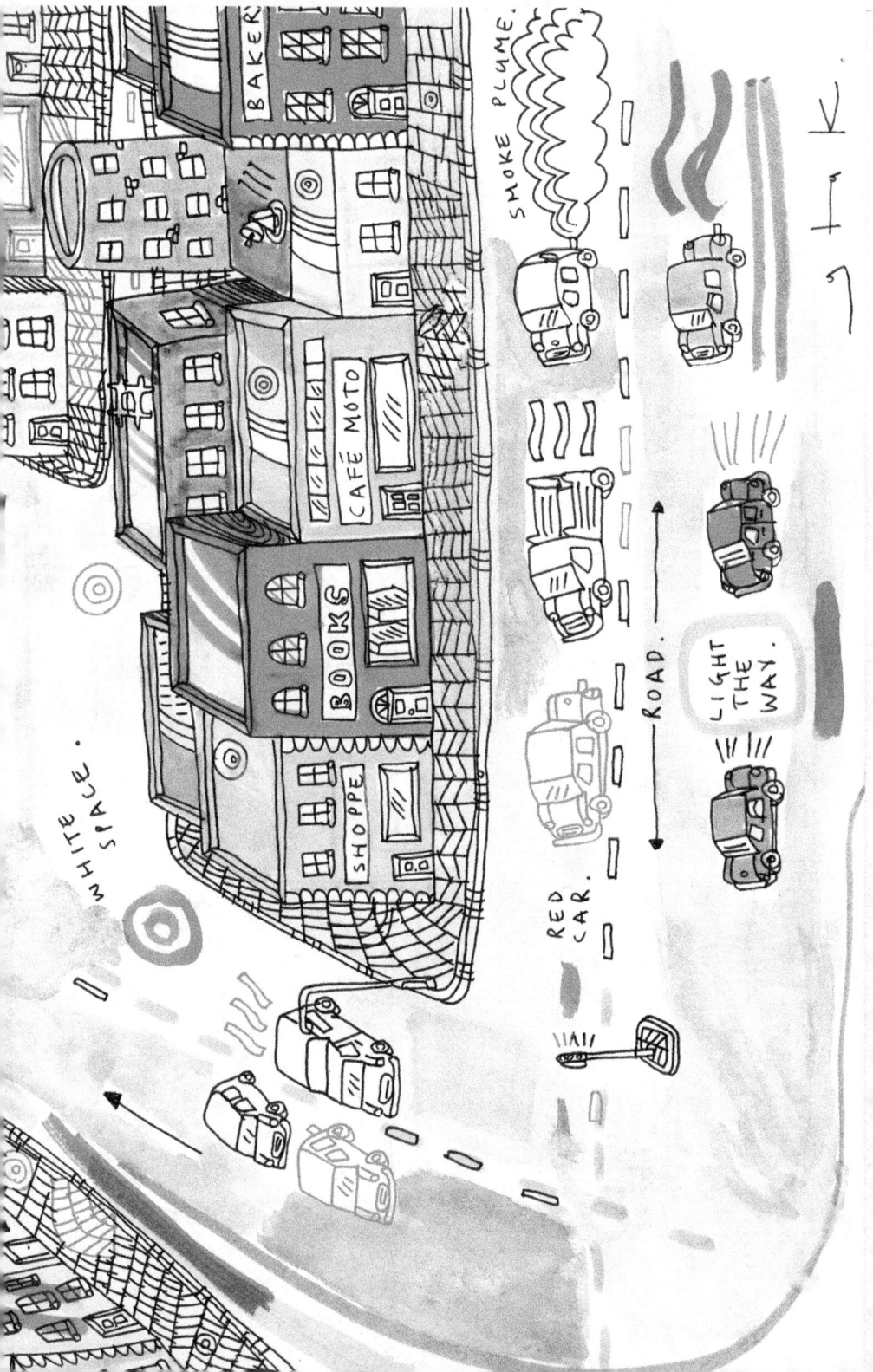

# Tim Comic

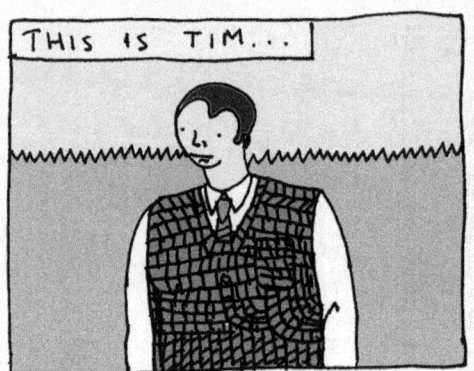
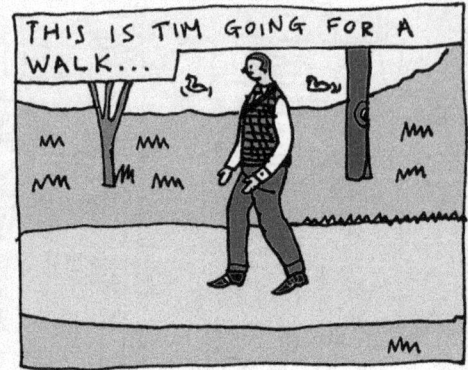
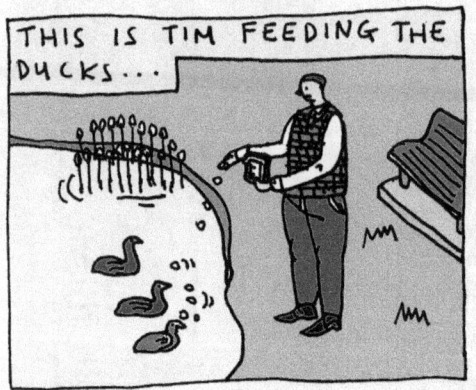
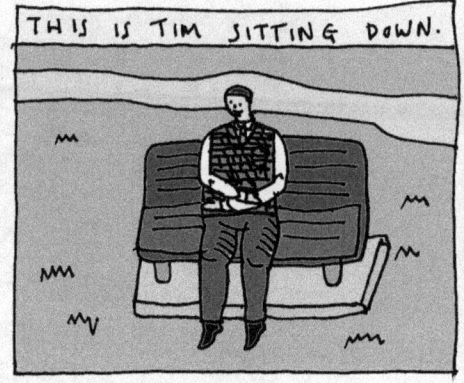
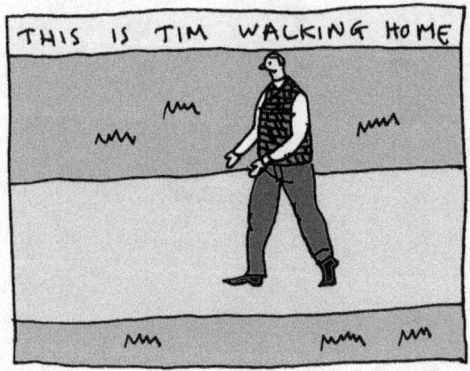
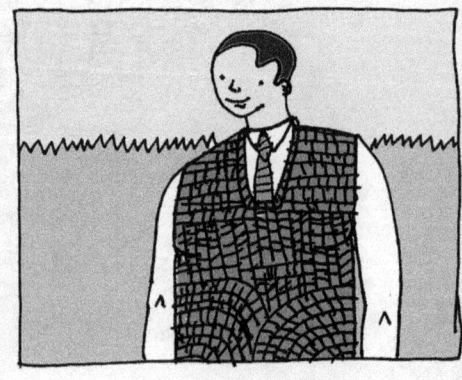

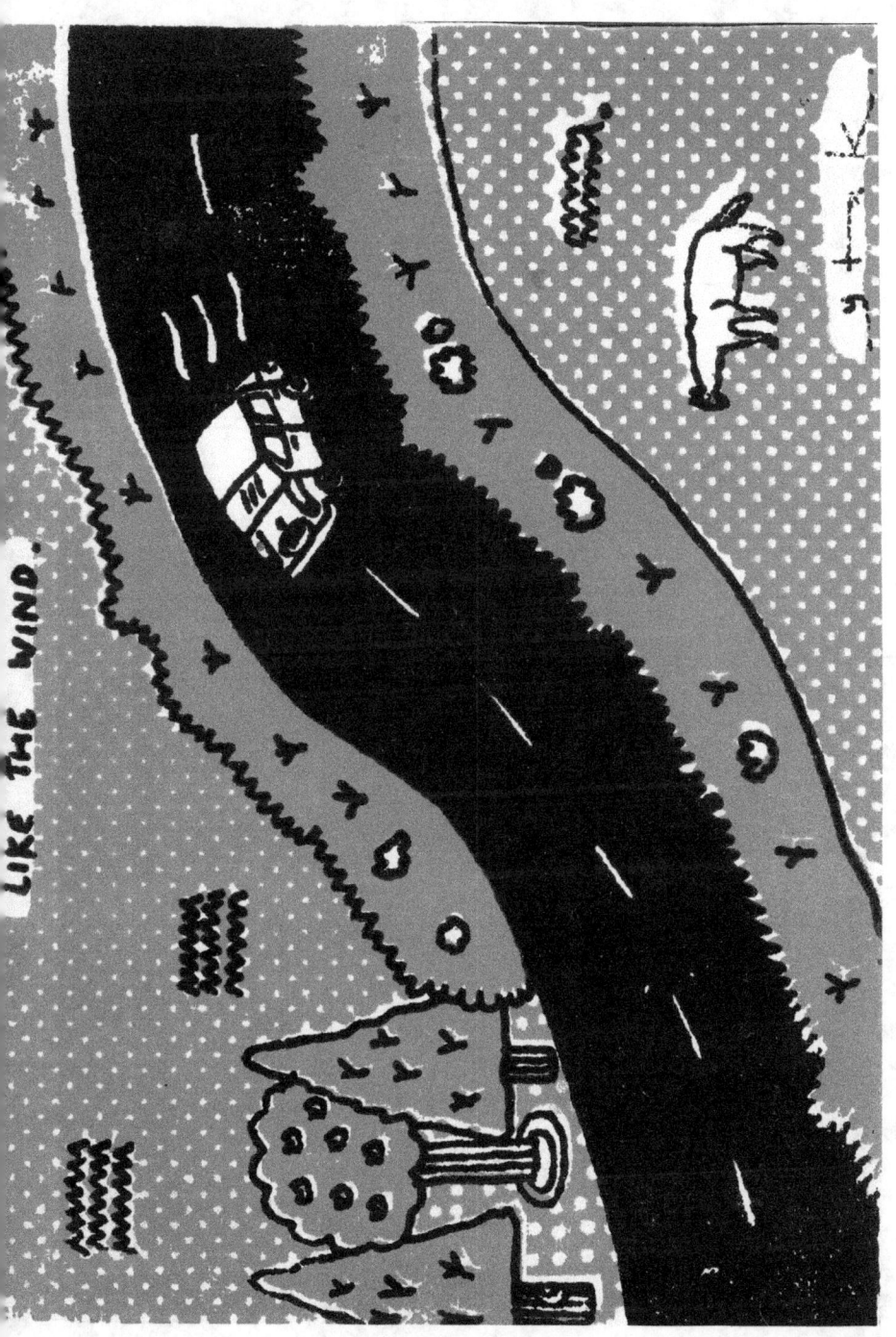

Like the Wind screenprint

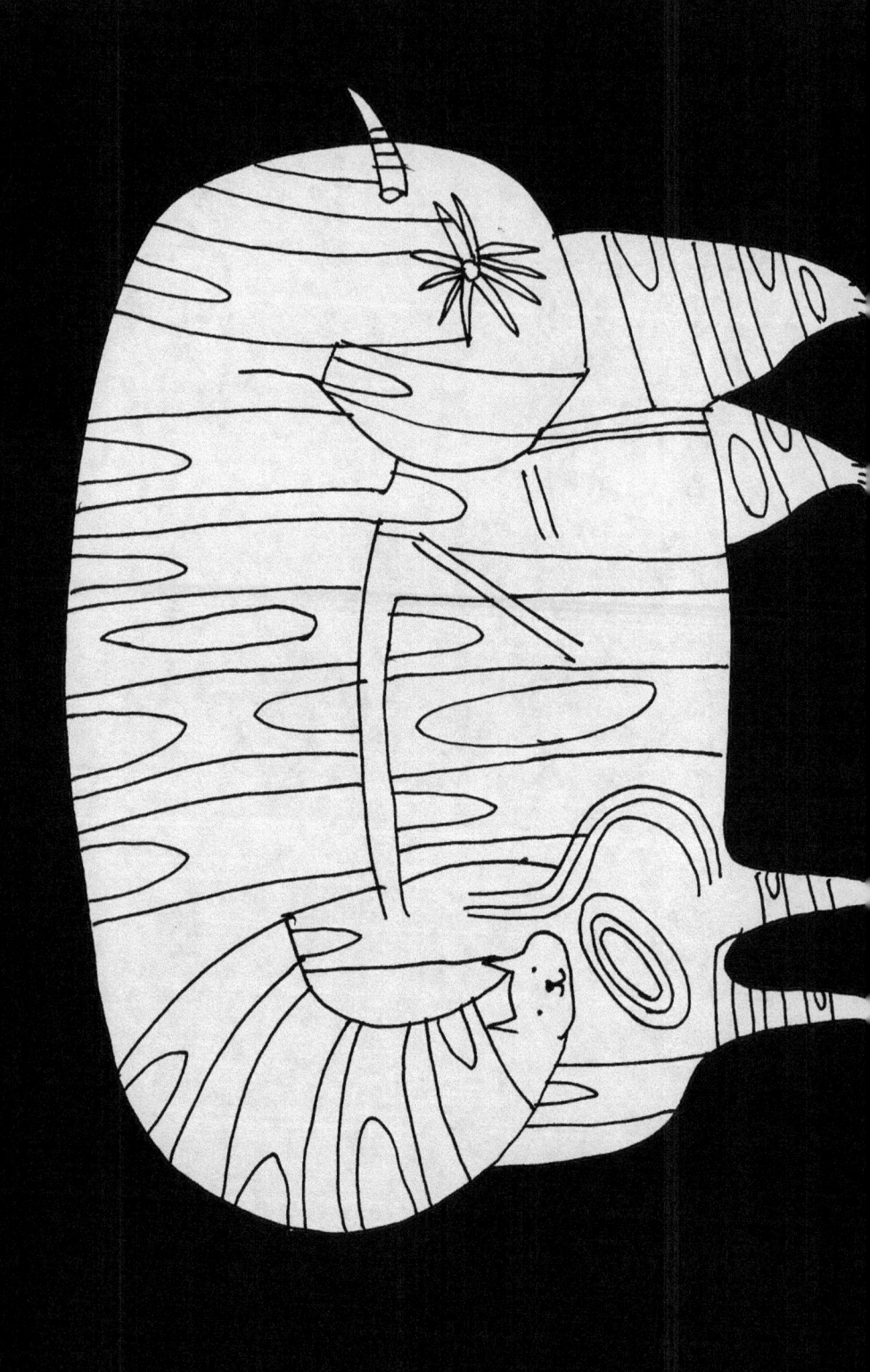

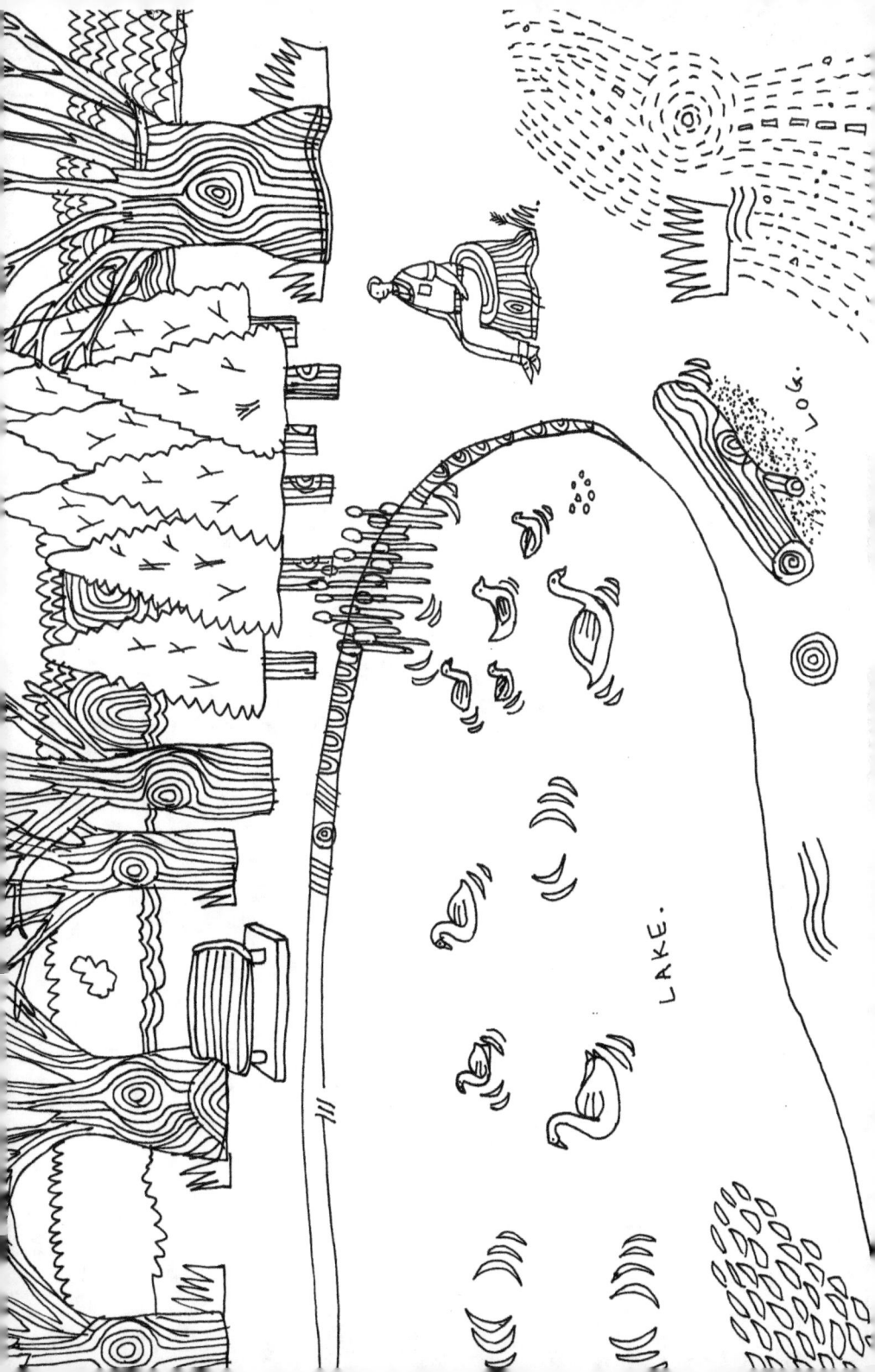

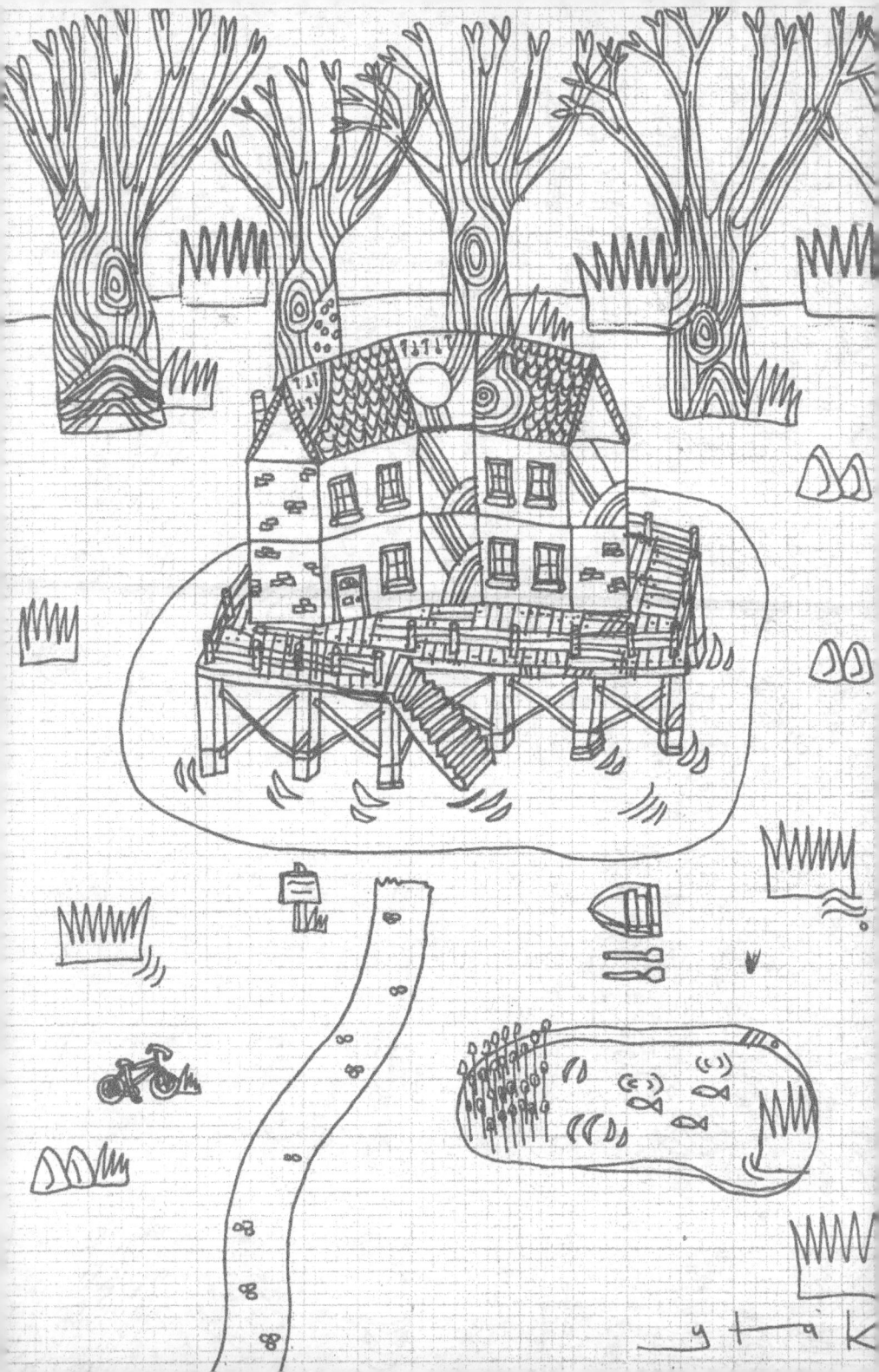

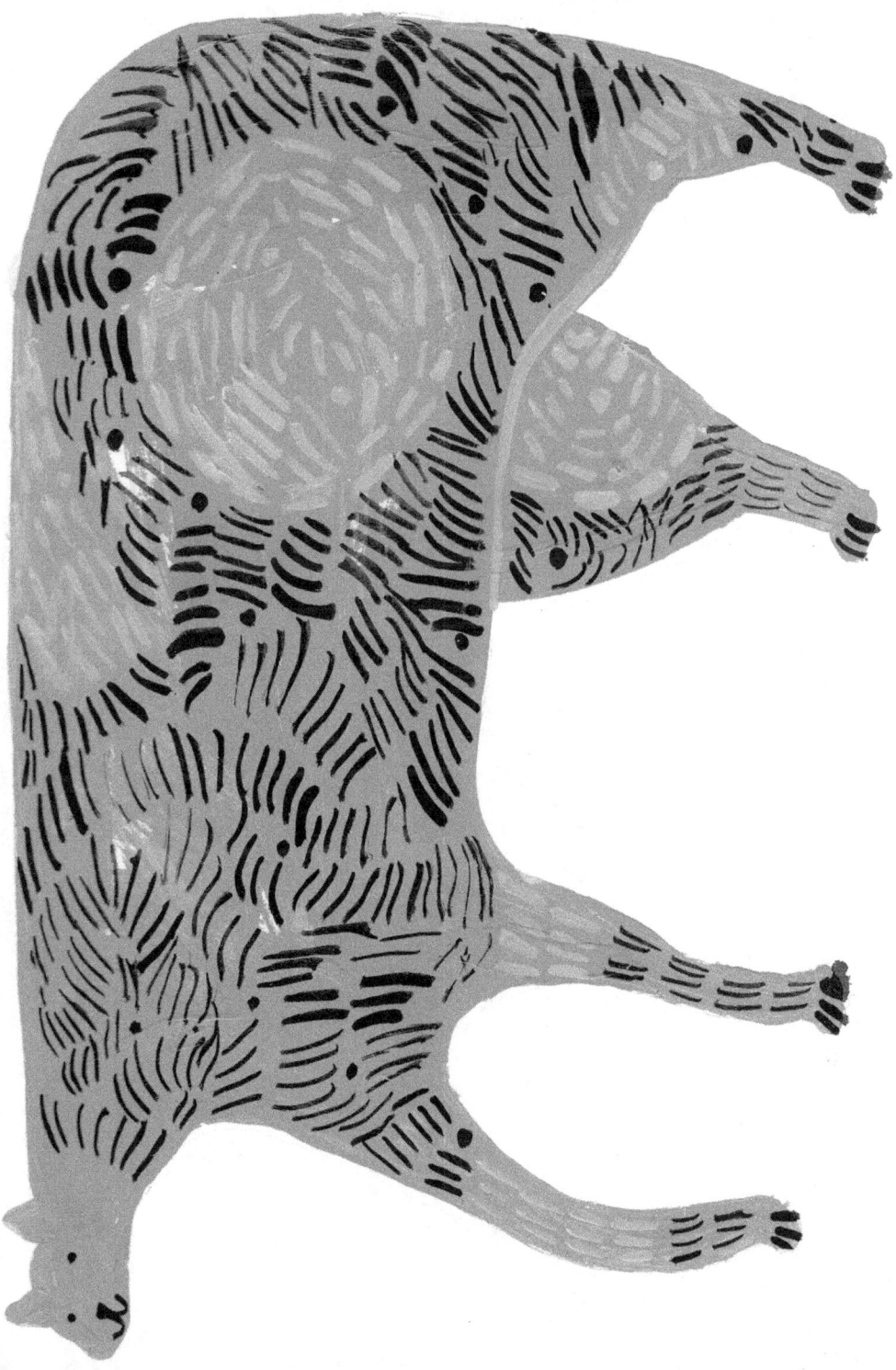

# Many thanks

To my family + friends. To everyone who has supported me.

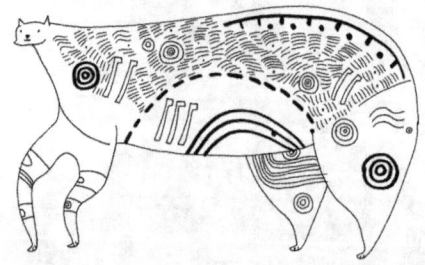

www.ingramcontent.com/pod-product-compliance
Lightning Source LLC
Chambersburg PA
CBHW072259170526
45158CB00003BA/1106